For Grace

Texas , Gay Lesbian,

Mexicans Materials

A

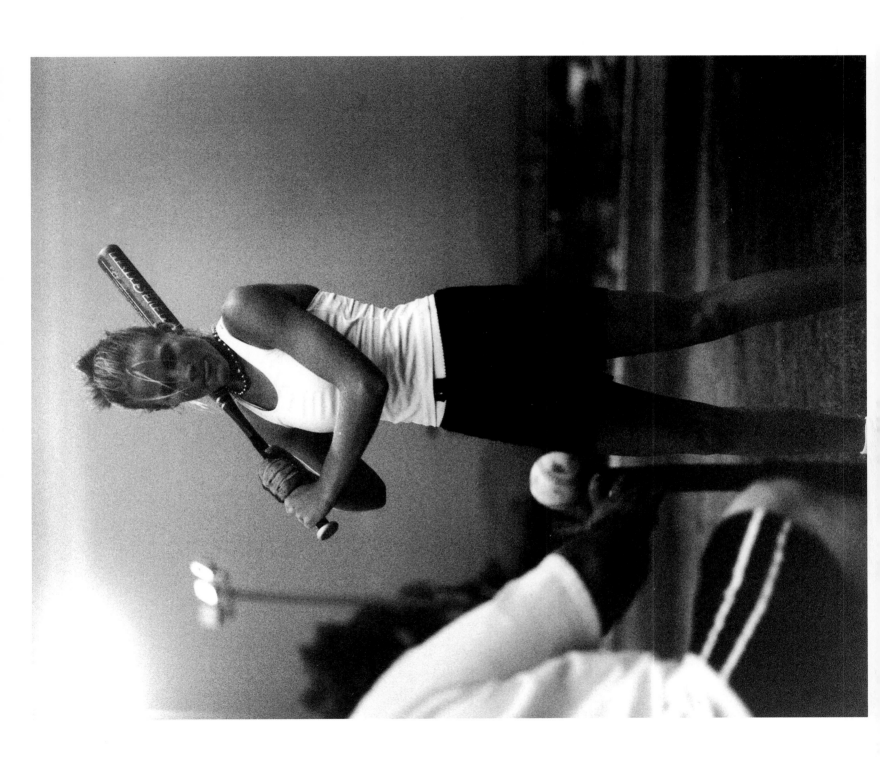

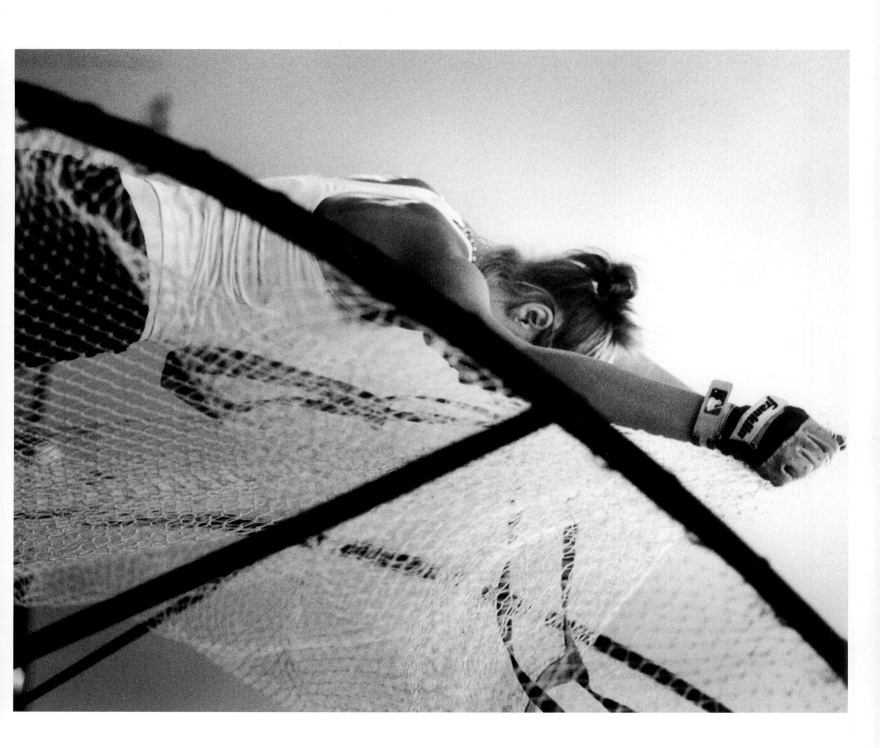

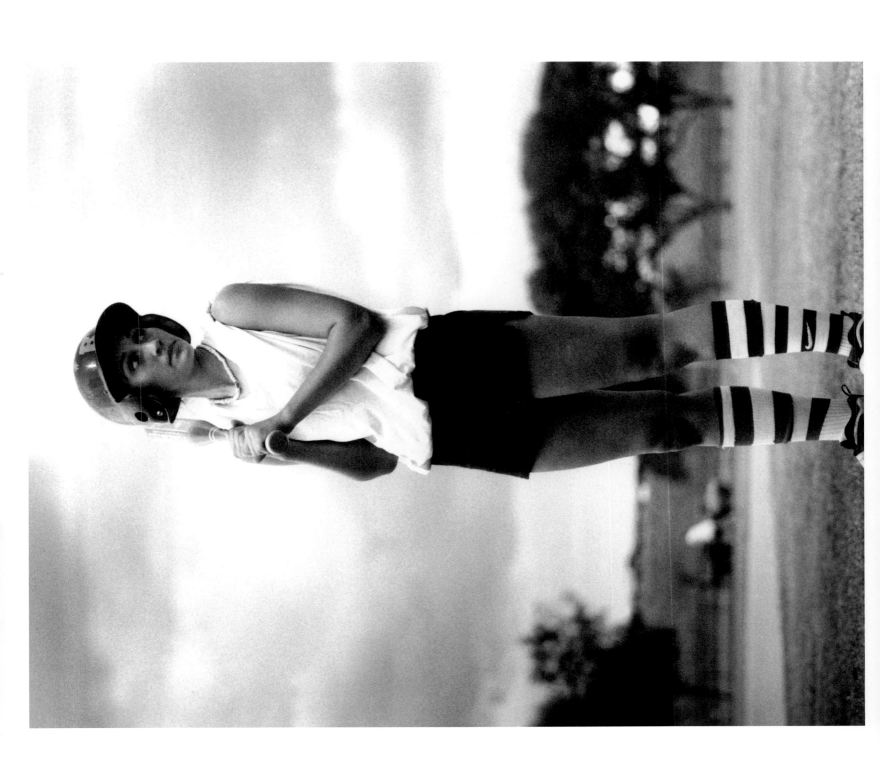

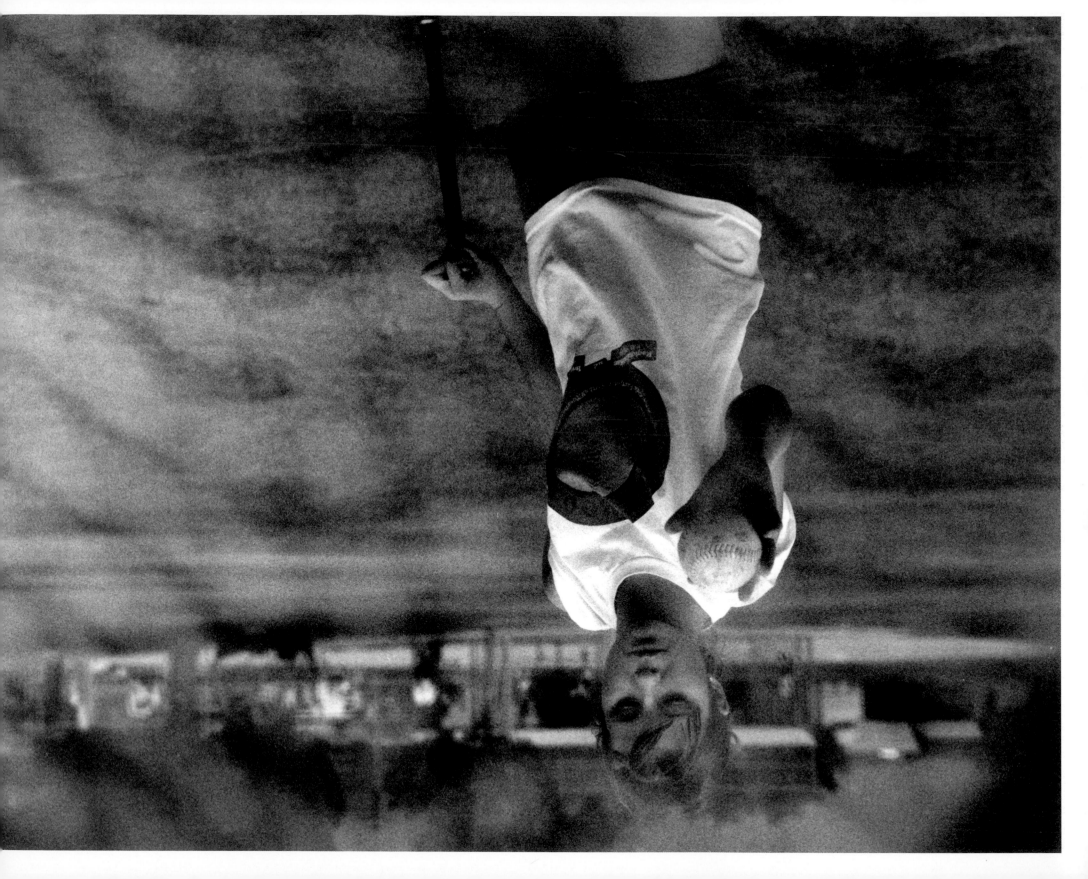

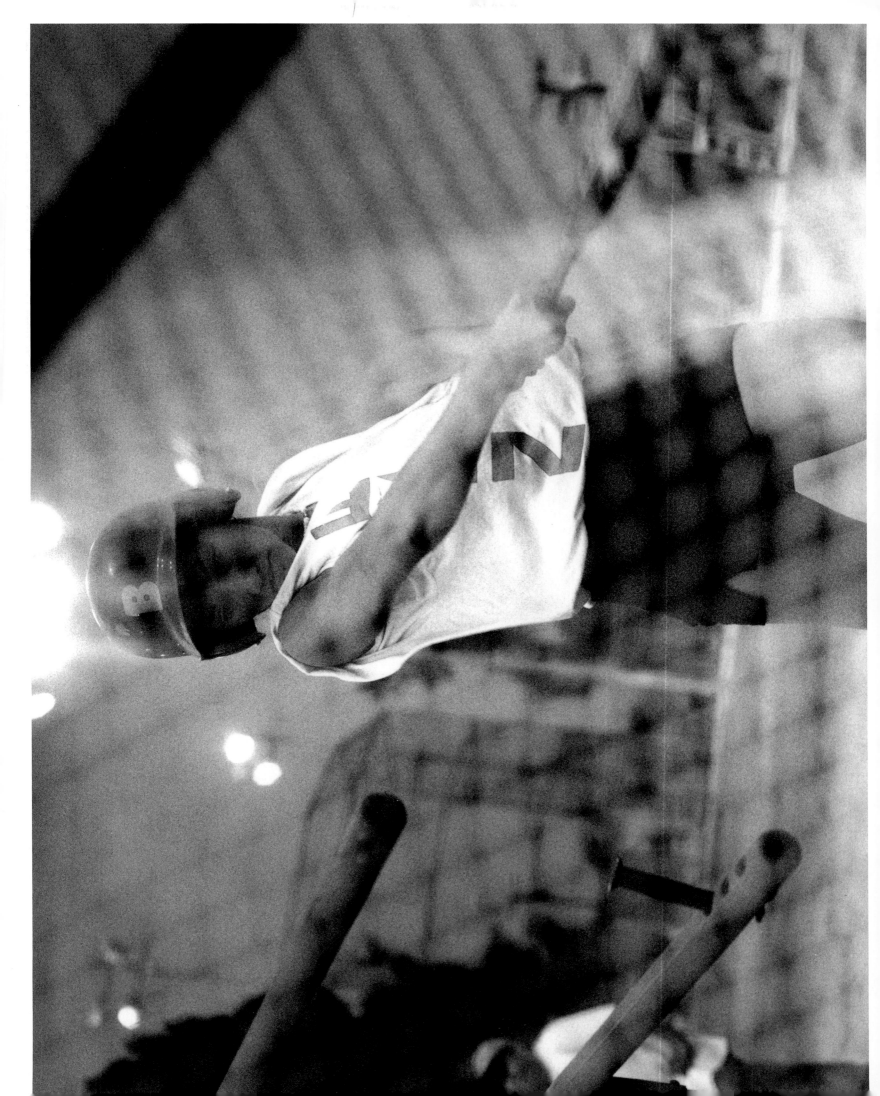

BOBCATS ERIC PAYSON

ESSAY BY ROBERT SOBIESZEK
EDITED BY MARK HOLBORN

powerHouse Books
New York, NY

ERIC PAYSON'S BOBCATS

William Henry Fox Talbot, one of the inventors of photography, said it right from the beginning: an artist's "eye will often be arrested where ordinary people see nothing remarkable."[1] Arrested by the beauty, meaning, pathos, or resonance of the most ordinary scenes and details of daily life, artists with cameras have been creating remarkable images for more than a century and a half. Photography has been and remains uniquely capable of stilling (arresting) those chance associations, subtle continuities, and graceful adjacencies that lie embedded in the fabric of what surrounds us. Neither the camera's format nor the speed of the film have anything to do with this fundamental capacity of the medium. For some photographs, think "correspondence" or "equivalent;" for others, think "decisive moment," or "snapshot aesthetic."

Of course, format and speed do play vital roles in certain genres of photography, especially those that involve action such as combat, theatrical, and sports photography. With hand-held cameras and with relatively fast exposure times, modern and contemporary photography can record events as they happen and not as posed to simulate their occurence. There is a great difference between a shot of the "rearranged" dead at Gettysburg and that of a Vietnamese captive being assassinated. Similarly, a photo of Sarah Bernhardt posing as a dramatic character for the camera is different than one of cavorting nude actors of the Living Theater shot from onstage. And studio portraits of boxers taken in the 19th century are not even comparable to a close-up of Jersey Joe Walcott's face being hammered by a right cross from Rocky Marciano.

It is hard to conceive of anything approximating sports photography prior to Alfred Stieglitz's race track scene of 1904, or Jacques-Henri Lartigue's autoracing shot of 1912. Sure, there were chronophotographic studies of athletic motion in the 19th century, but these were not of actual events. Montages of soccer action were published in Werner Gräff's modernist manual *Es kommt der neue Fotograf!* of 1929, and John Gutmann's gravity-defying *Diver* was shot in 1936, the year the Berlin Olympics was well documented by both photography and film. Since then, sports photography has become a mainstay of print and broadcast journalism, often featured above the first-page fold of daily newspapers and as the lead on the evening news. Even postmodernist artists have turned to sports photography. Tracey Moffatt's 1995 series about Australian women's roller derby squads in staged action and Sharon Lockhart's images of a Japanese women's basketball team shot in pretend stop-action in 1997 are but two that come immediately to mind.

There are styles and approaches to photographing sporting events, probably as many as there are photographers in the field. John Szarkowski nicely contrasted two photographs taken of football games by Garry Winogrand more than twenty years apart. The early one, taken in 1953, is dark, grainy, forboding, and probably taken at a muddy game. Like the powerful football images taken by the award-winning photojournalist Robert Riger in the same decade, Winogrand's photograph concentrates on the fundamental essence of the game: the confrontation between the player carrying the ball and the charge of the defensive tackler. The later picture, taken in 1974, could not be more different. Using a much wider-angle lens, Winogrand captured all of the game's twenty-five players and referees in a vast and deep panorama of "chaotic violence." Szarkowski expressed it well: the "meaning of the first picture seems perfectly clear; the second simplifies nothing but achieves nevertheless an ordered pattern of fact that we had not seen before."[2]

Eric Payson's recent photographs of the Bobcats, a Tucson-based girls' softball team, achieve such ordered patterns of fact and a lot more. Here is a pictorial glossary to the game as played and lived by teenage girls: from practice to an actual game, from being counseled by coaches to horsing around, from idling along the sidelines to flexing their muscles both on and off the field. Payson particularly has captured the nuanced stances and strides of the sport: the explosive gymnastics of pitching and hitting, the dynamics of the group and the isolation of the individual, the intensity of concentration and the poignancy of failure. All of this Payson discovers within the geometries of chainlink fencing and portable catch nets.

As if to emphasize that they are playing in the high desert, a number of shots show players drinking out of cups, bottles, and beverage coolers. There are also images of the team entering or leaving the field under the yellow glare of night lights that appear like some avant-garde dance performance. There are shots of a player taken from what appears to be a car's rearview mirror, looking very much like a proud young competitor steeling herself for contest. And there is a remarkable photograph of a young pitcher at the crest of her delivery. Her left leg streches forward while the right one bends in counterbalance, her left arm pointing her gloved hand toward the unseen catcher while her right arm strains upward clutching the ball just before releasing it. The formal lines and tensions of this figure suggest a cross between some Hellenistic figure of an athlete and a Bauhaus dancer in a costume made of cones and cylinders.

We have all learned from Roland Barthes' *Camera Lucida* that all photographs are contingent but none are coded. Excluding digital imaging, photographs are grounded in contingency; they require that some thing or things had to be present in front of the camera to be recorded. Without a code or a caption, however, documentary photographs reveal little that is certain about their meaning. Editors and advertisers know this all too well. Yet even the lack of codes or captions may be virtue. The American critic John Bayley offered some sage advice about contingency in literature: "Because we live in contingency, a poetry can be wholly contingent and yet make out of that very circumstance its own power to focus and to fascinate..."[3] Payson's images seem to suggest a photography that fully embraces contingency as well as its associations, continuities, and adjacencies.

Even though the ostensible subject of *Bobcats* is a girls' softball team, Payson does not treat it like a traditional documentary photographer. The norm of modern photography has been to frame the subject from the outside looking in. From Henri Cartier-Bresson to Robert Frank, this approach made very good sense. Since Robert Smithson's landscape photography of the 1960s and Lee Friedlander's street photography of the 1970s, and certainly since Gilles Peress' decentered take on the Iranian revolution in the 1980s, the dynamic between the photographer and subject has notably shifted. The strategy of looking at something situated at some remove from the camera is no longer as confidently undertaken as it once was. More and more, documentary projects are constructed to portray the subject from within as much as from without. Privileged singularity of vision has been replaced by a complicitous mulitiplicity of viewpoints.

Insinuating himself within the daily routines of the team and not just its games, Payson creates a rich, intimate, and most likely honest pictorial record of the Bobcats. We may never know whether the young girl is holding her head in her hands out of fatigue or dismay. We may never discover who the mustachioed man in sunglasses and wearing a cowboy hat is. Nor will we ever find out if the batter over who's shoulder Payson took two shots ever hit the softball hurling towards her. But, then, it doesn't matter. What matters are the ordered arrangements of fact that Payson assembles for us so well.

An online book on girls' softball includes a chapter on terms and phrases specific to the sport. "Good Eye!" is one such phrase, but "just what this mean[s] as opposed to 'bad eye' no one has ever figured out."[4] This sounds pretty good here, if for no other reason than that the penultimate sentence in Jack Kerouac's introduction to Robert Frank's *The Americans* reads, "To Robert Frank I now give this message: You got eyes."[5] As *Bobcats* makes very clear, Eric Payson has eyes.

—Robert A. Sobieszek
Los Angeles, July 2001

Notes:
1 William Henry Fox Talbot, *The Pencil of Nature* (London: Longman, Brown, Green, and Longmans, 1844-46), text for Plate VI.
2 John Szarkowski, *Winogrand: Figments from the Real World* (New York: The Museum of Modern Art, 1988), 28.
3 John Bayley, "Richly Flows Contingency" (review of *Flow Chart* by John Ashbery), *The New York Review of Books* (15 August 1991), 3.
4 *Life in Girl's Softball: Stories Written and Compiled by Coach Greg English* (http://www.geocities.com/Heartland/Park/3099/chapter4.html)
5 Jack Kerouac, introduction to *The Americans* by Robert Frank (New York: Grove Press, 1959), unpaginated.

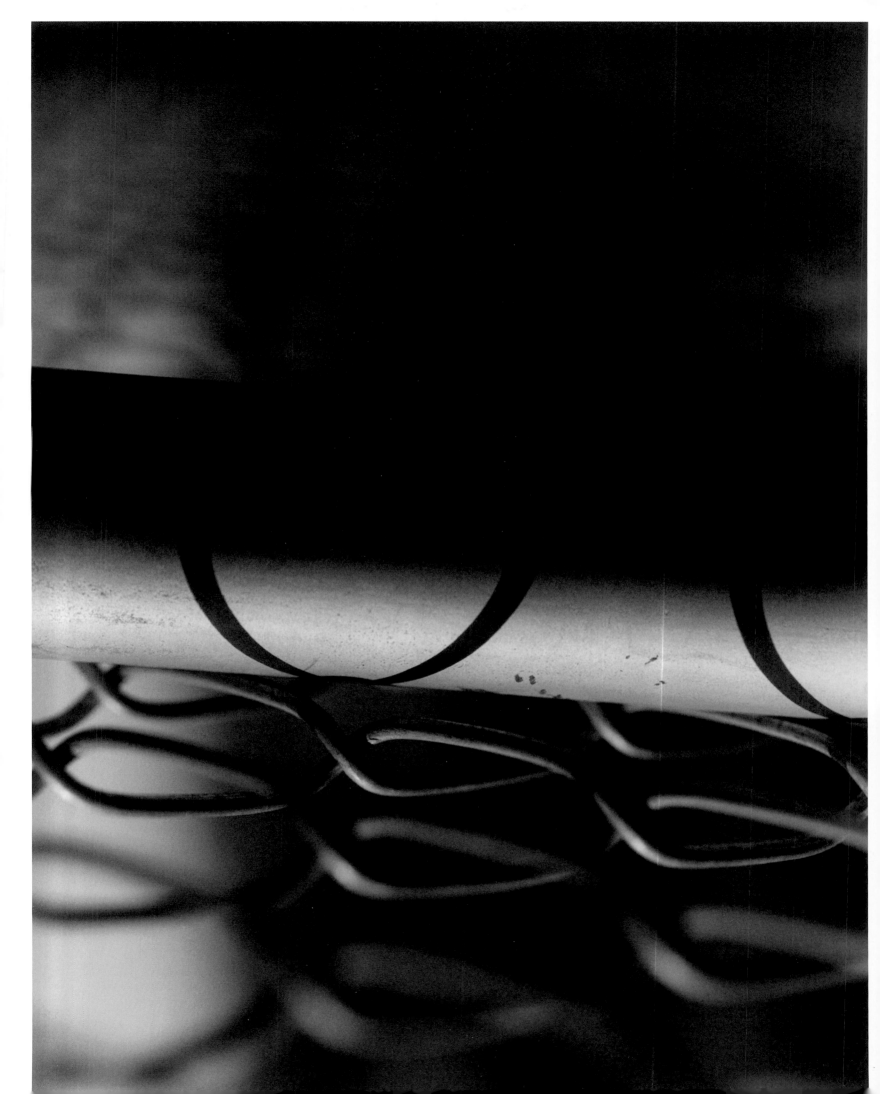

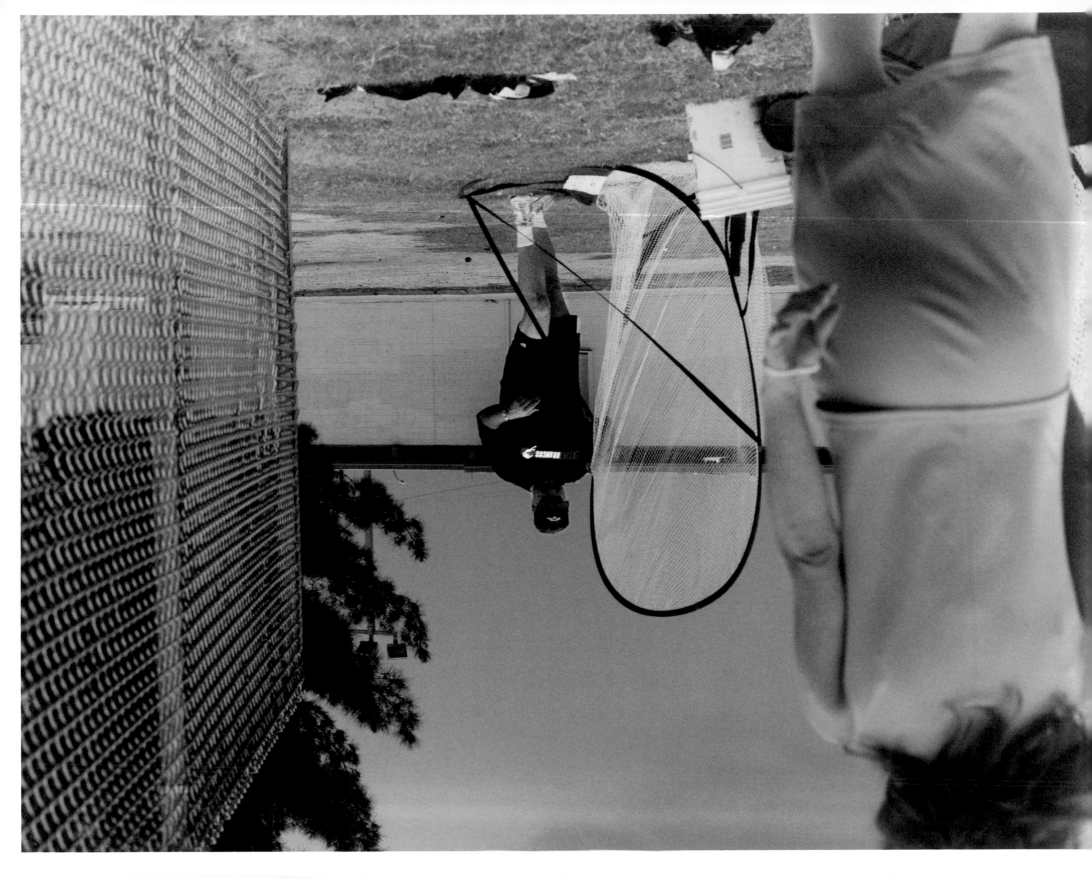

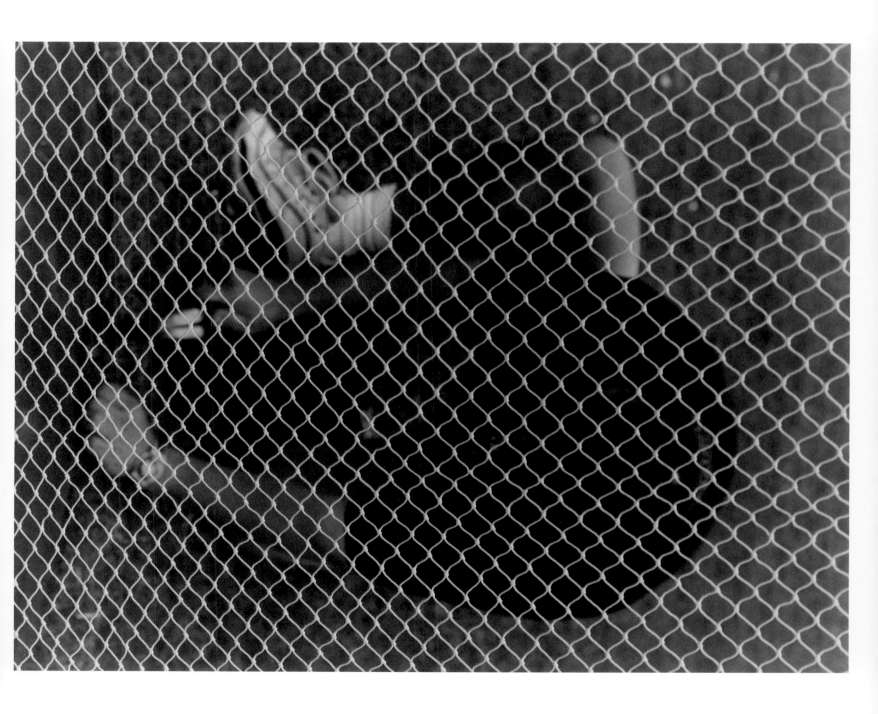

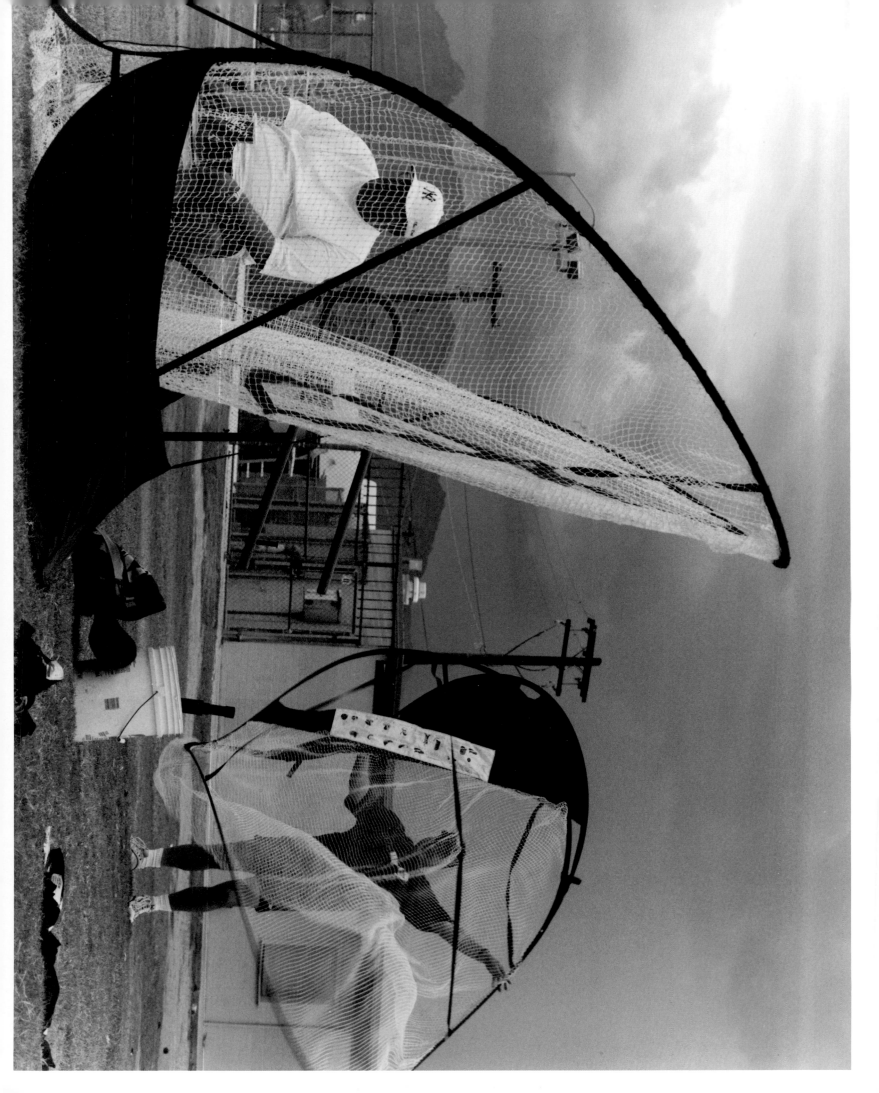

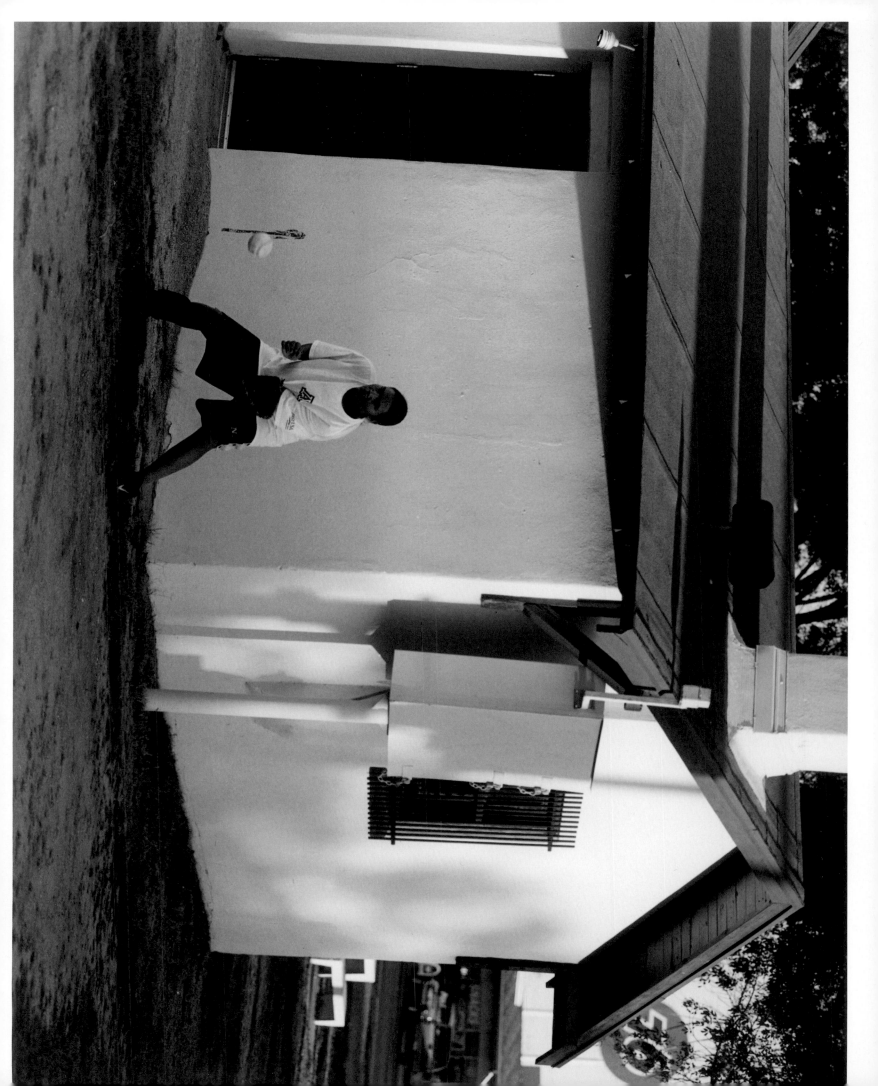

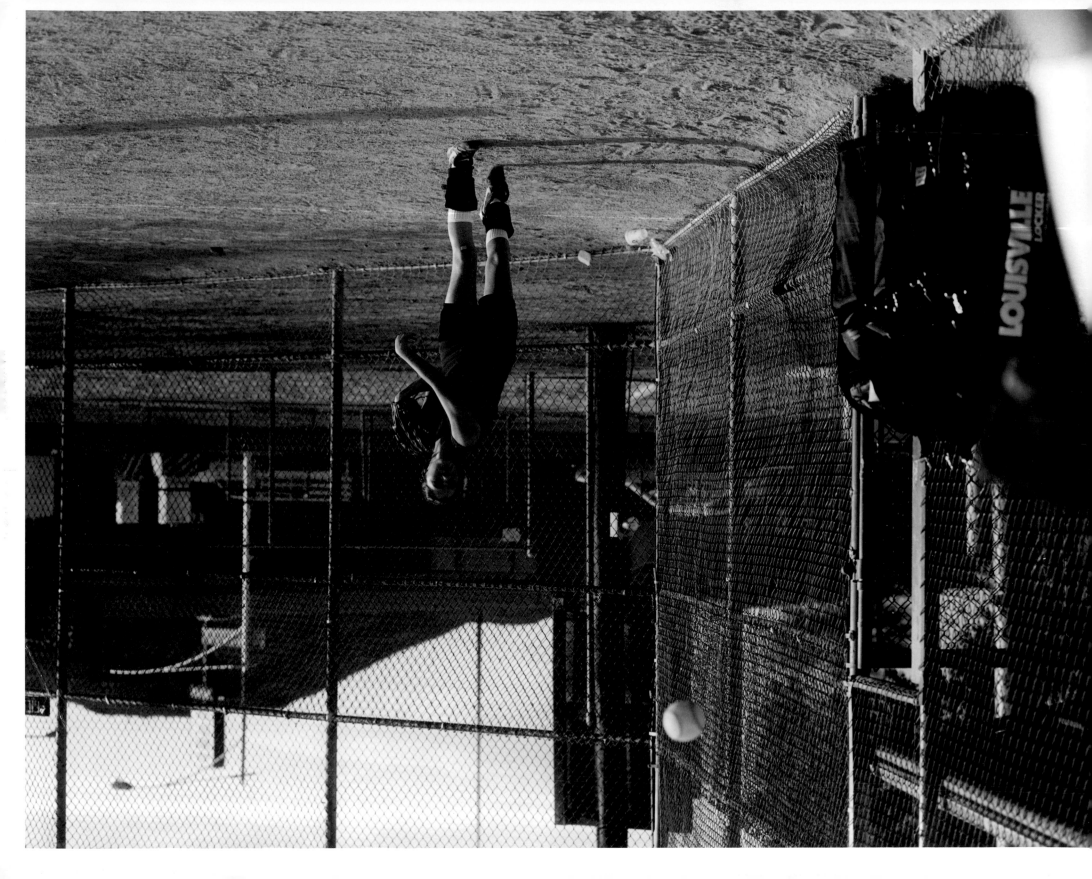

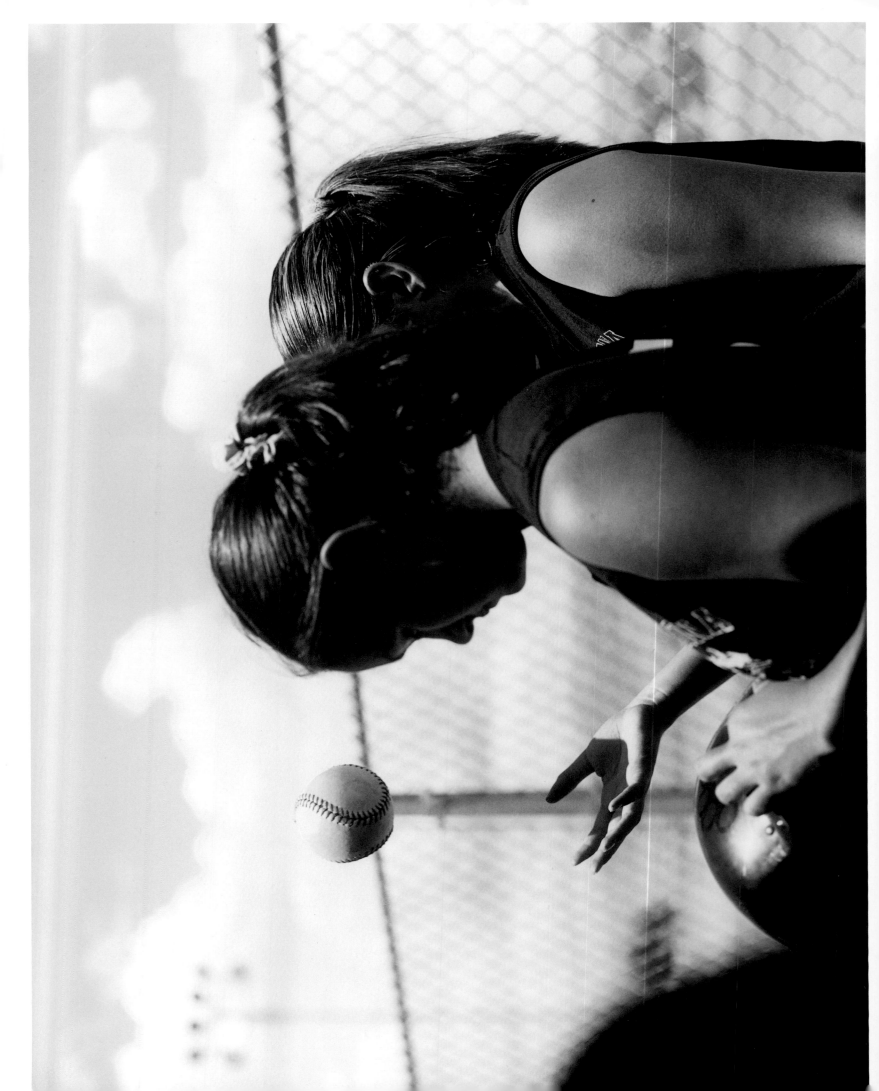

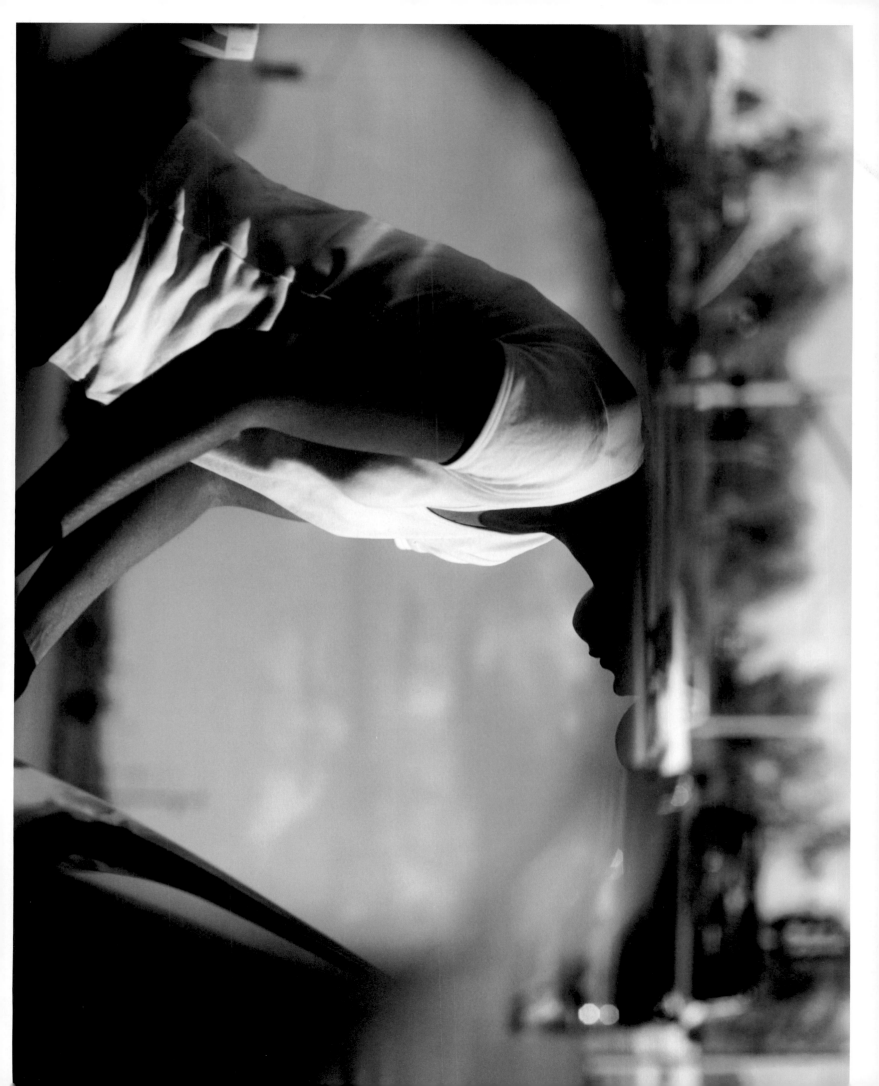

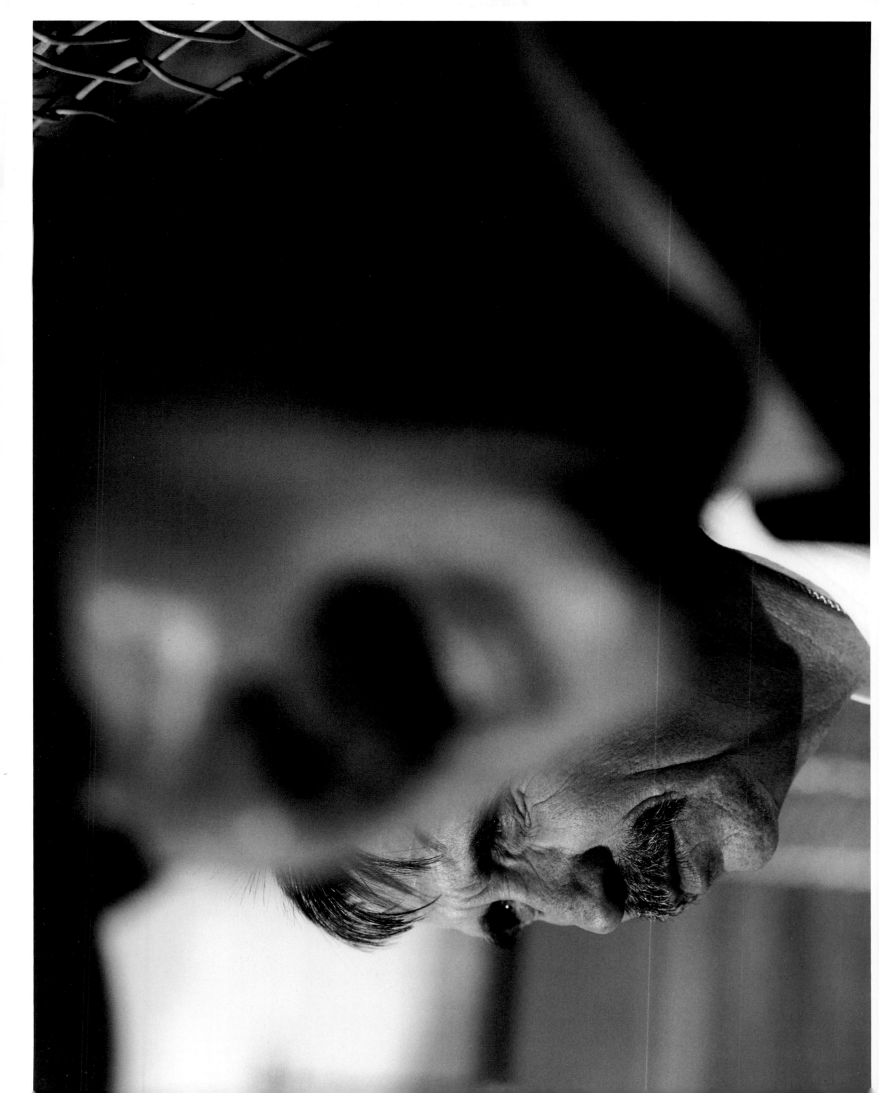

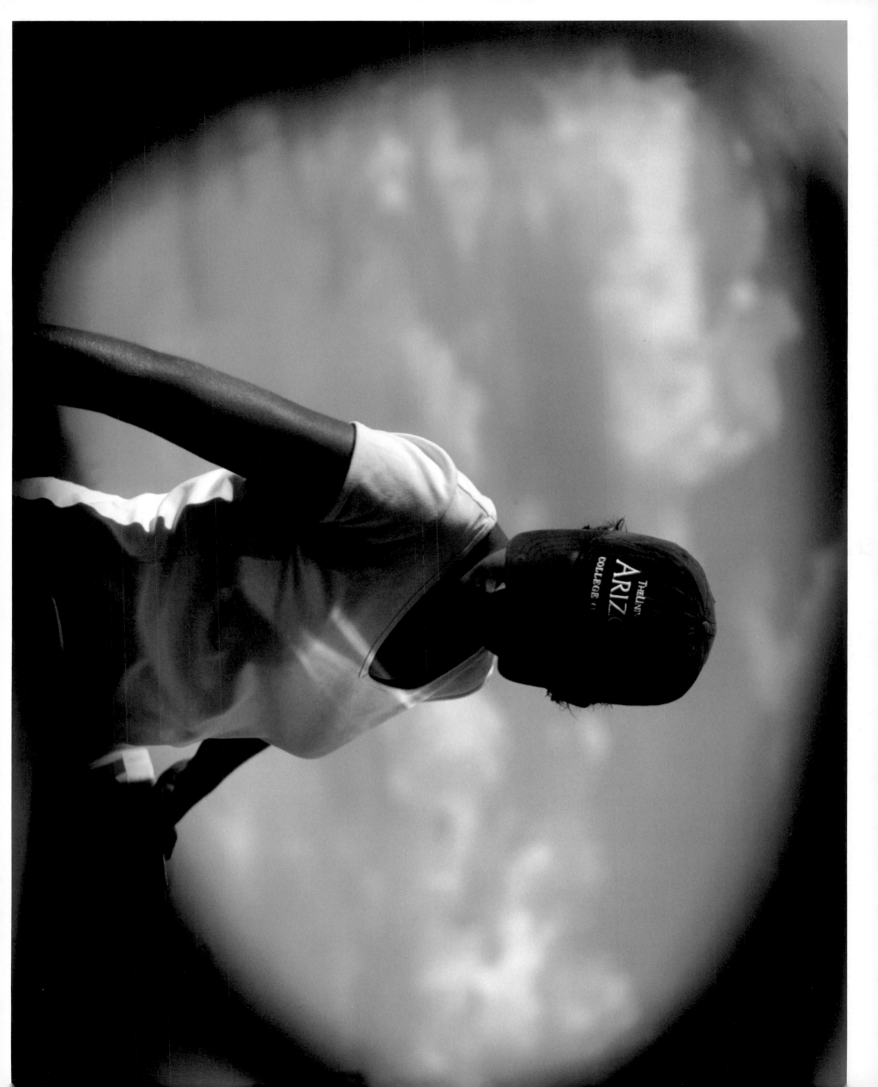

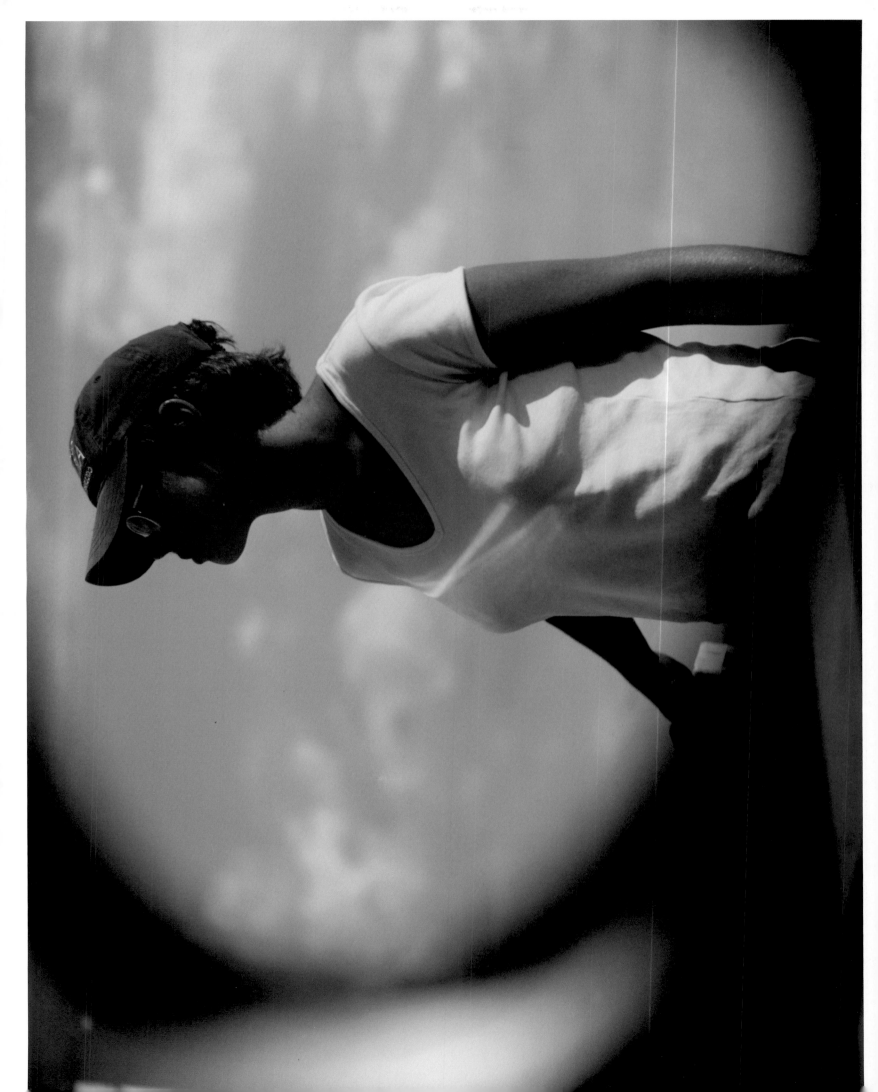

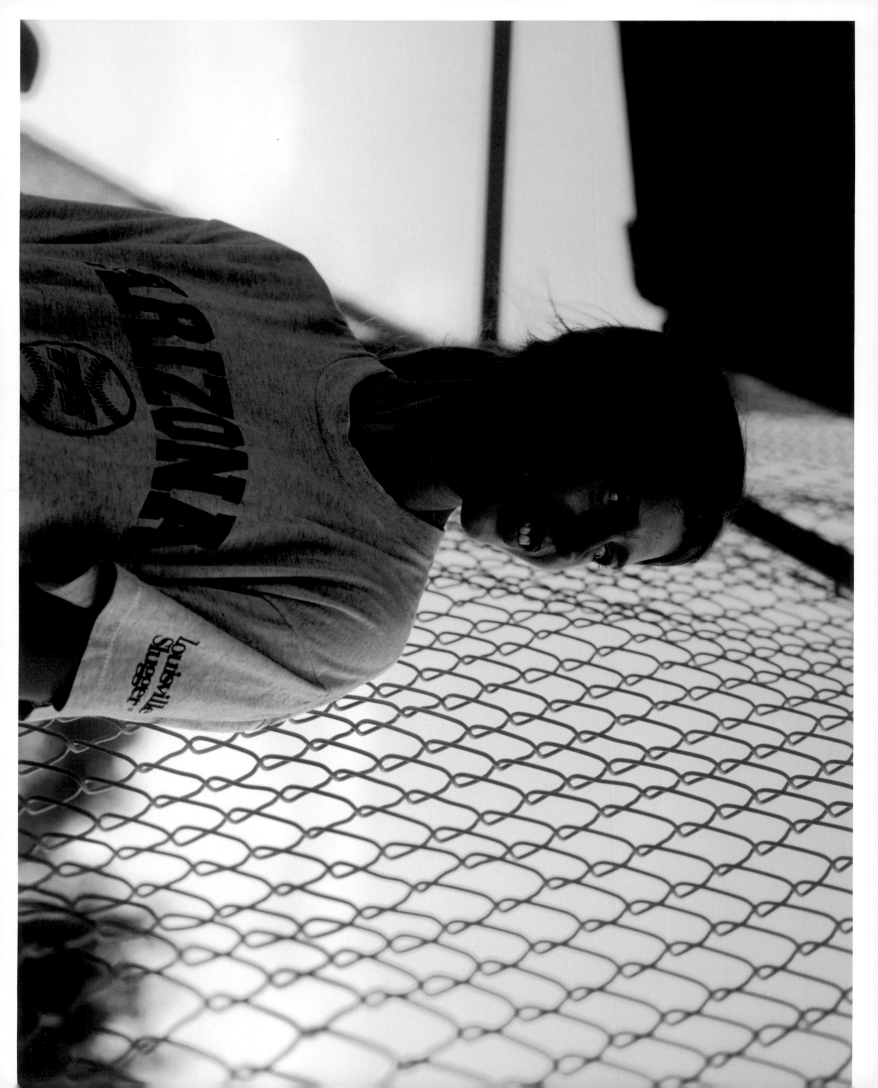

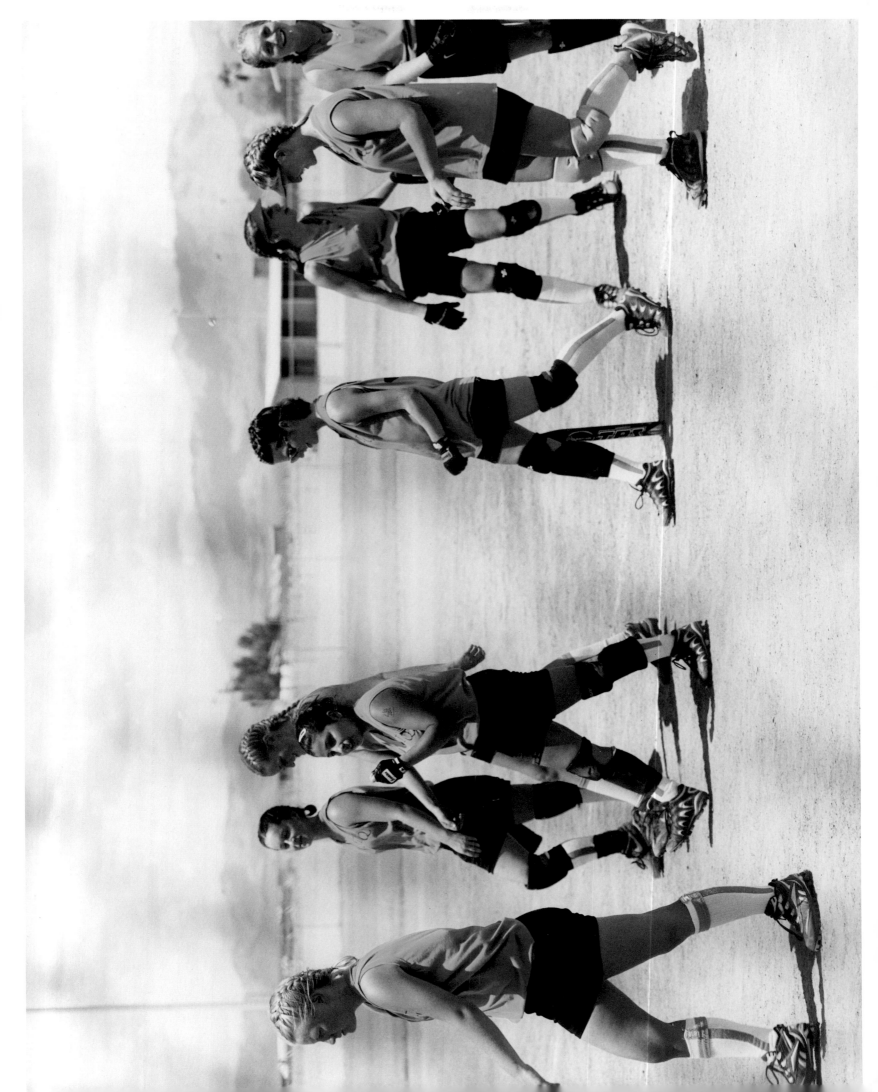

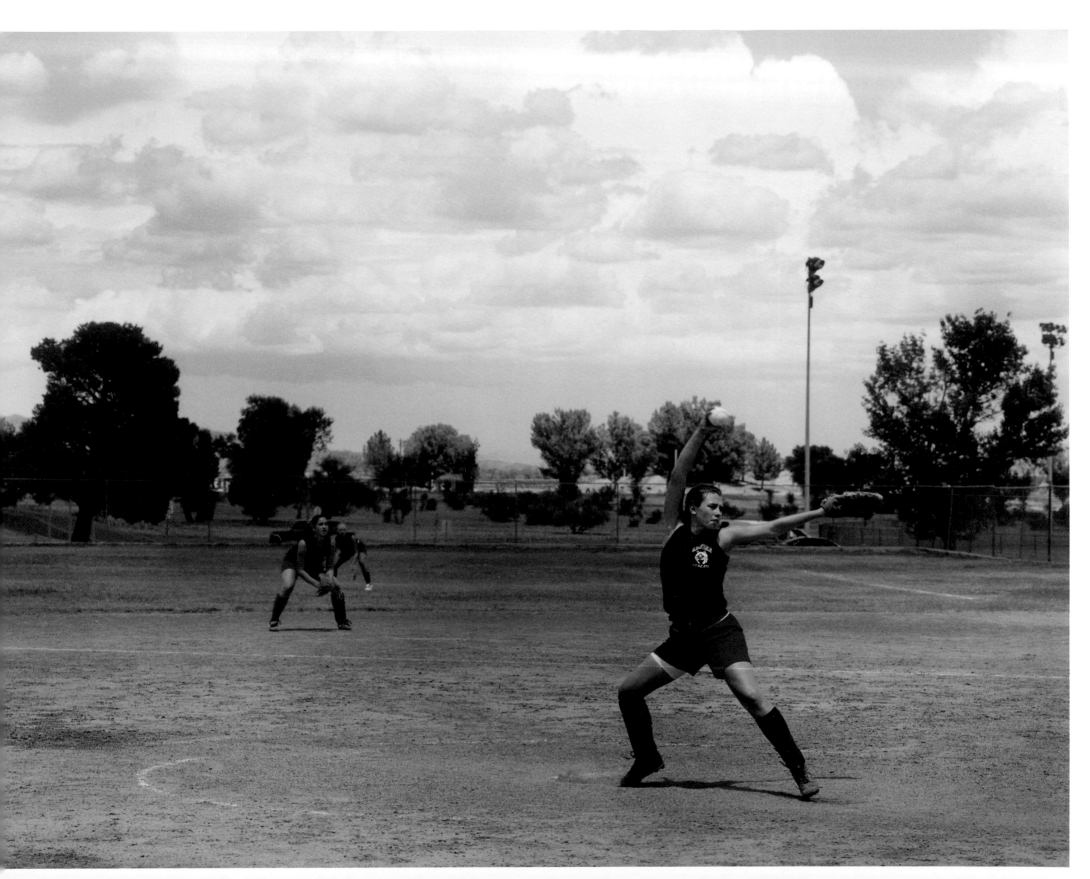

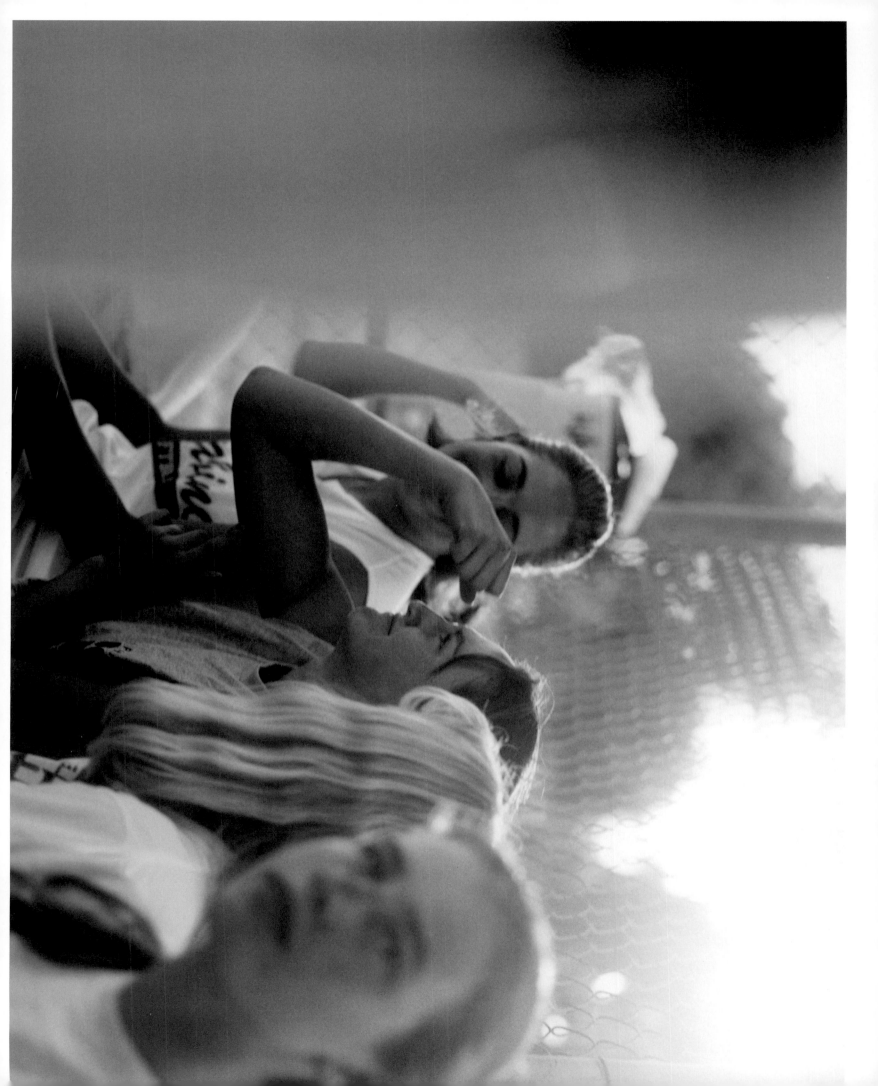

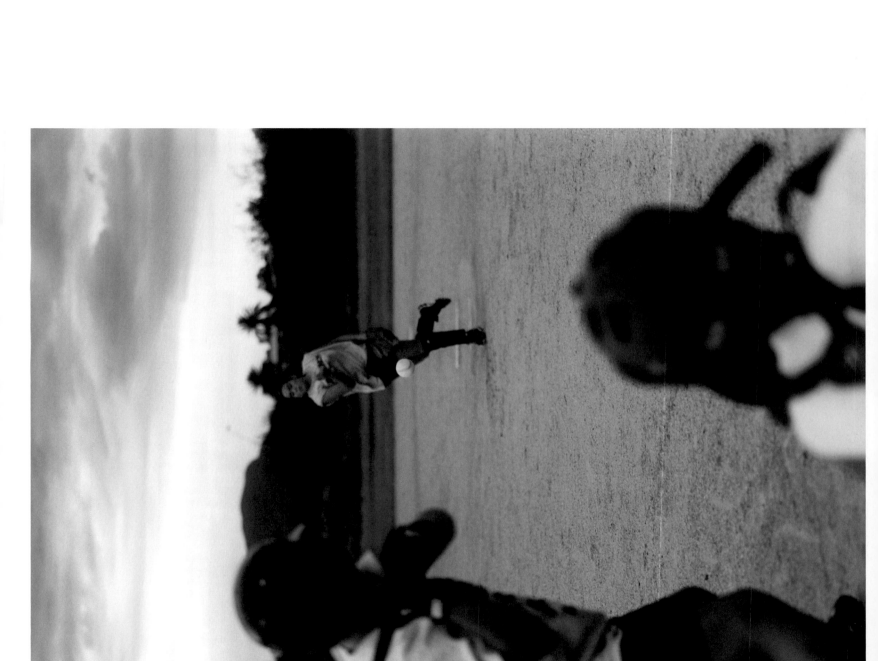

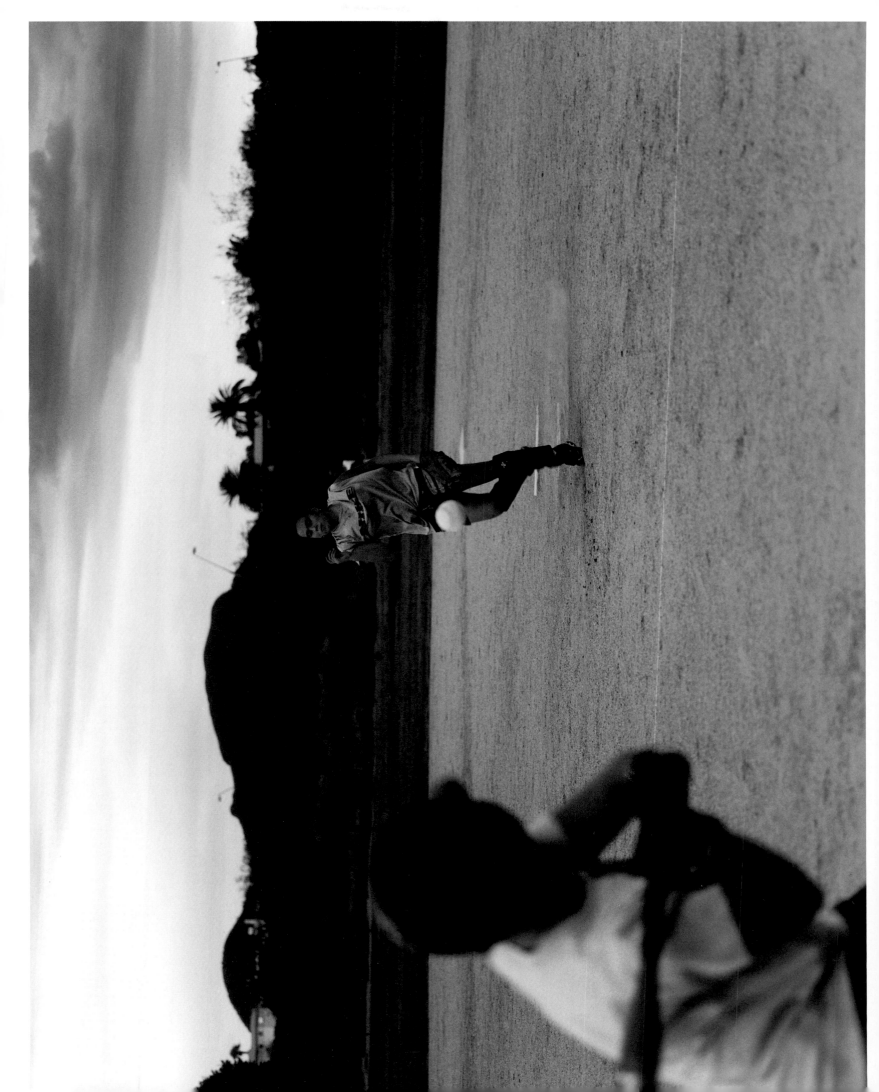

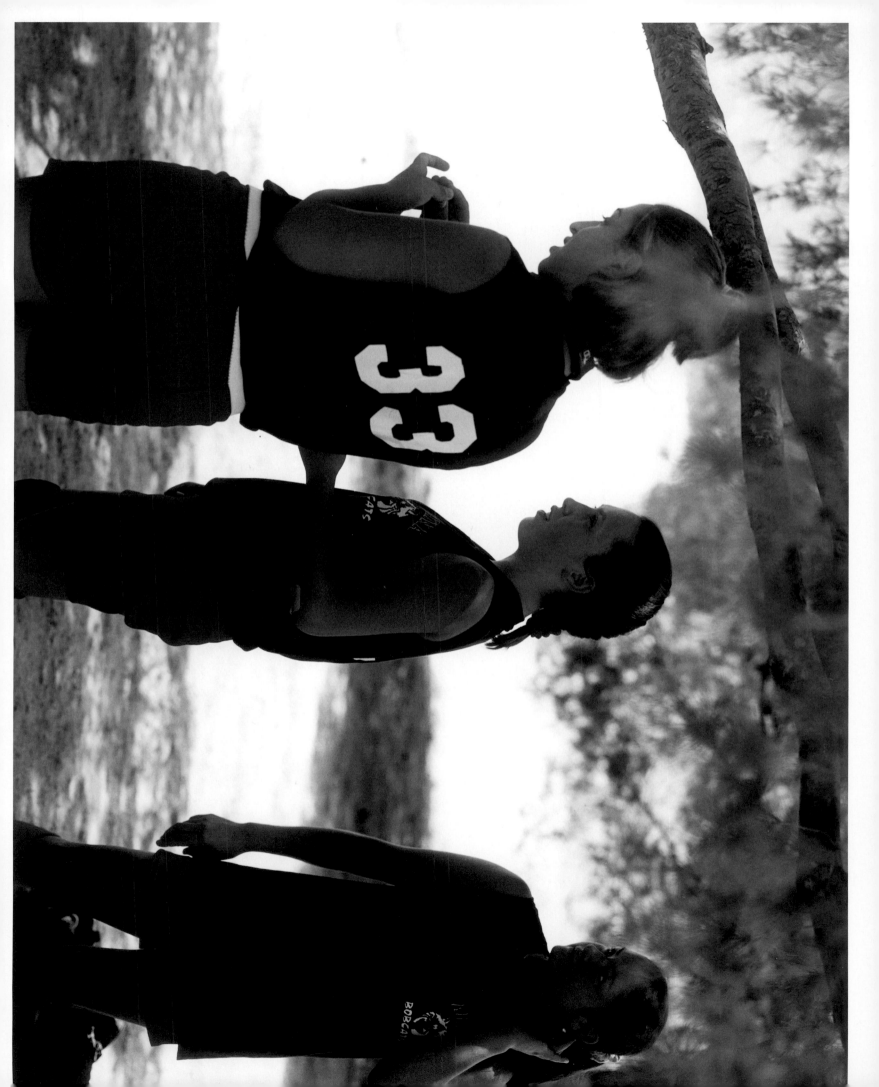

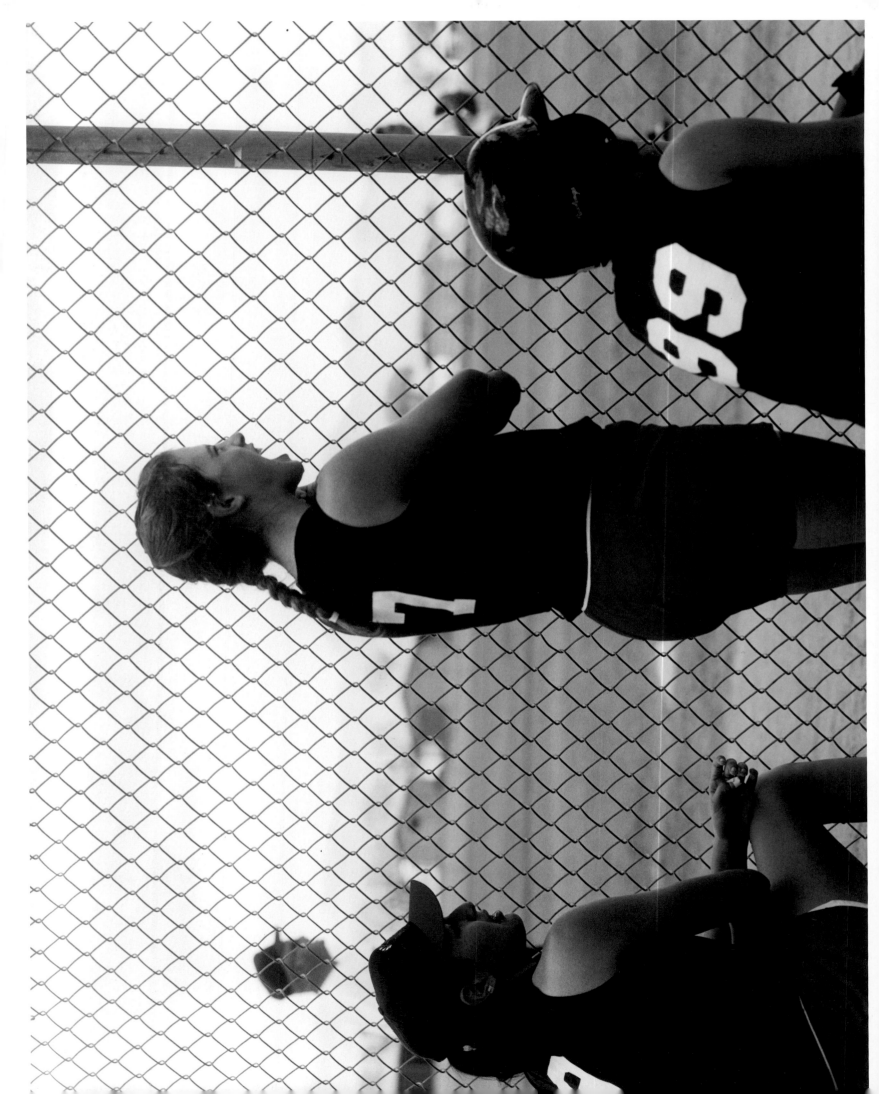

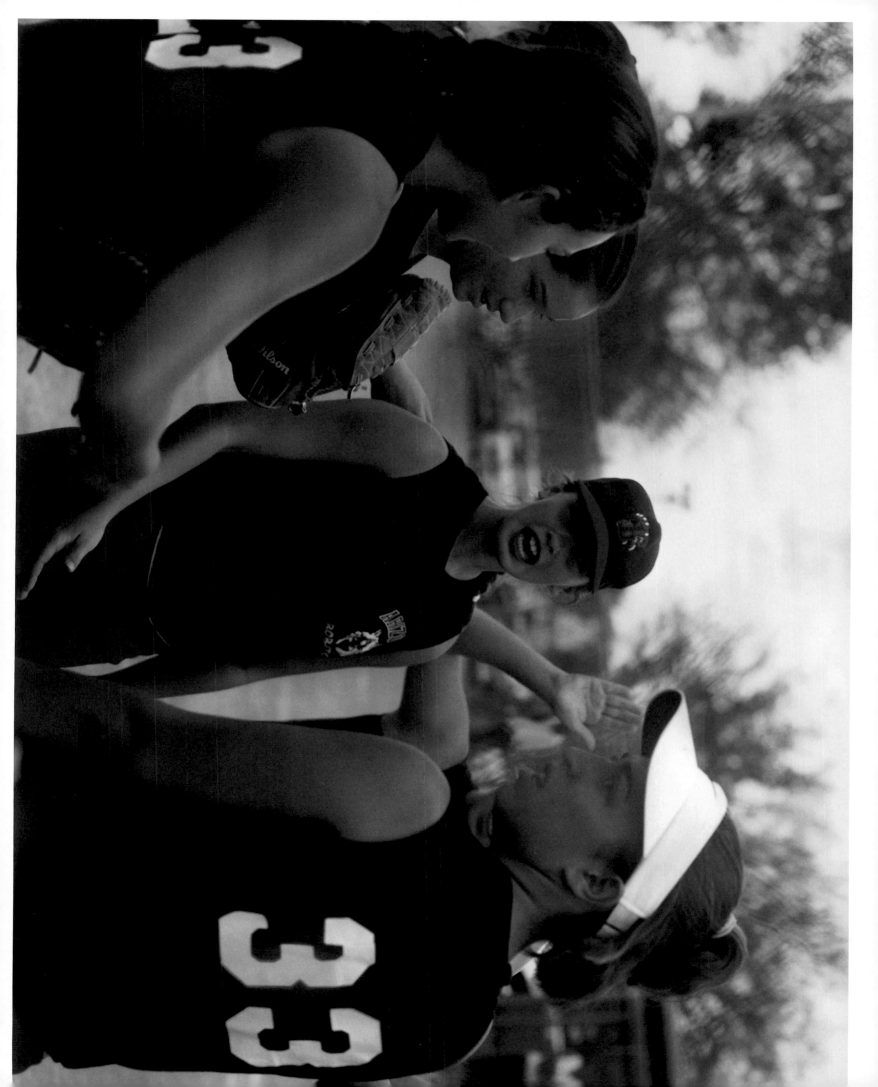

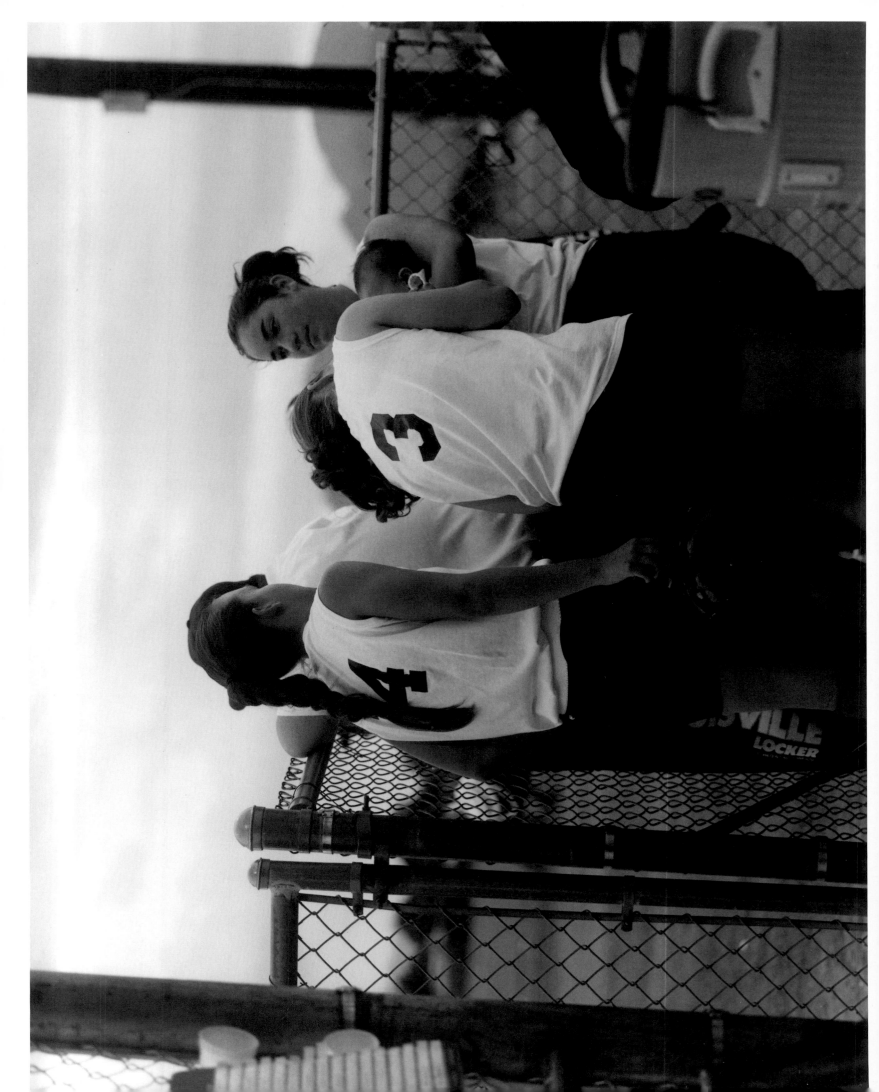

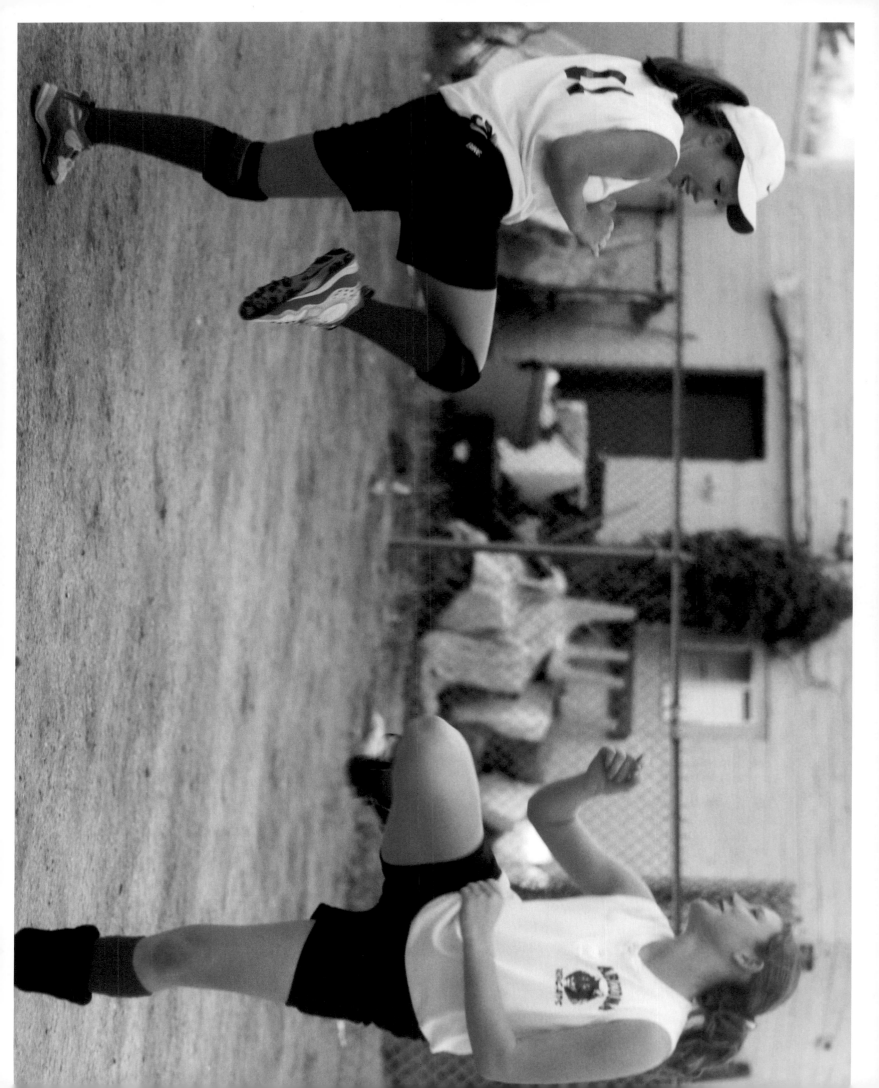

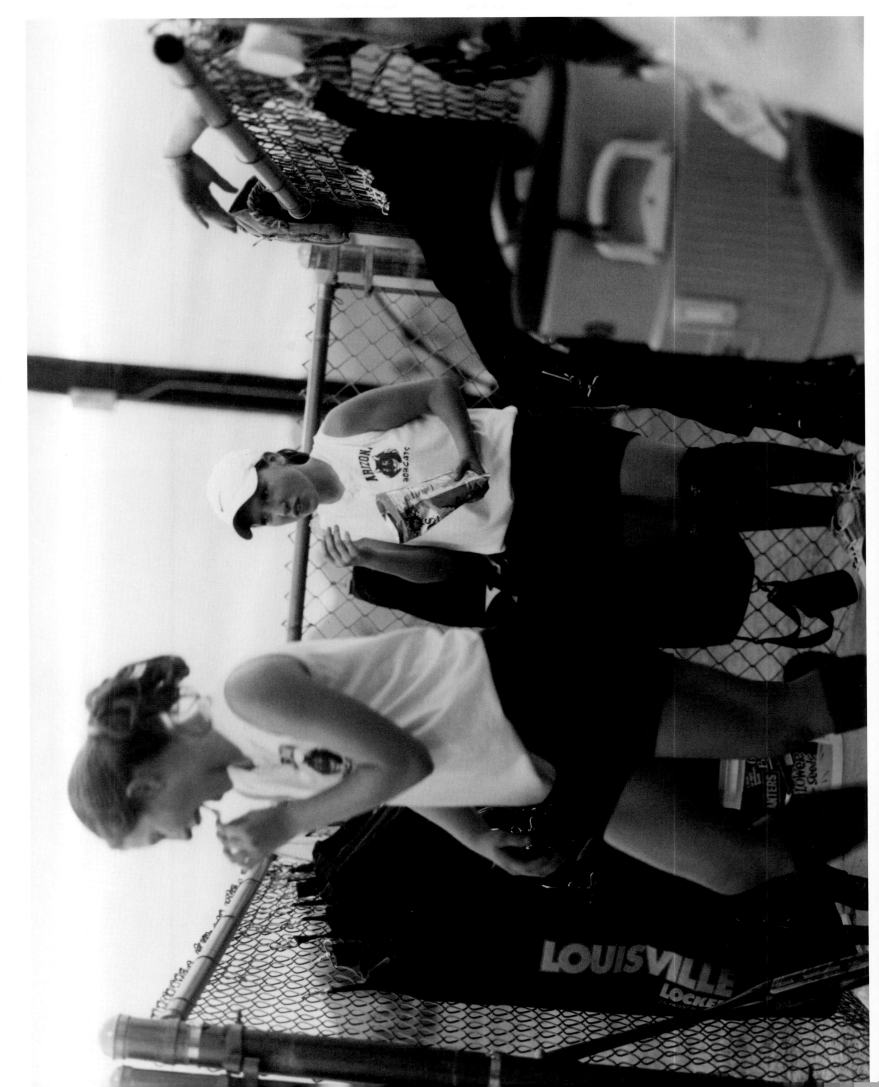

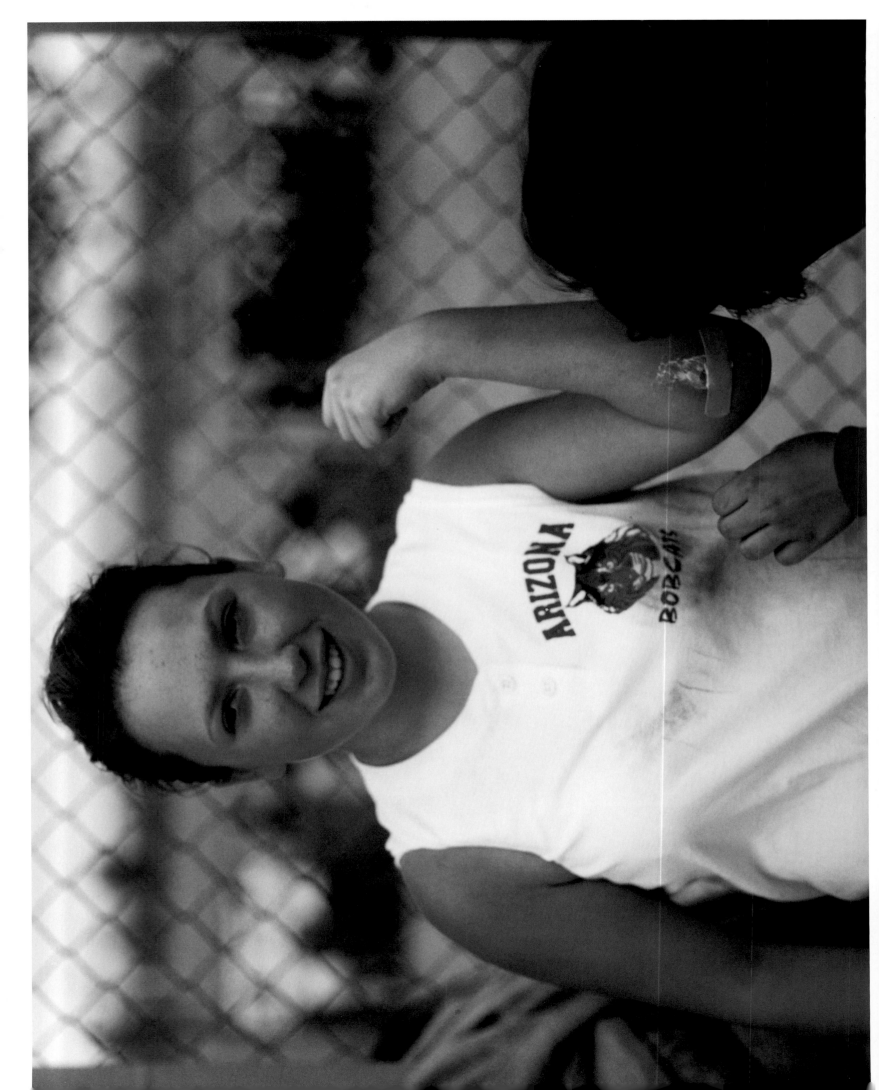

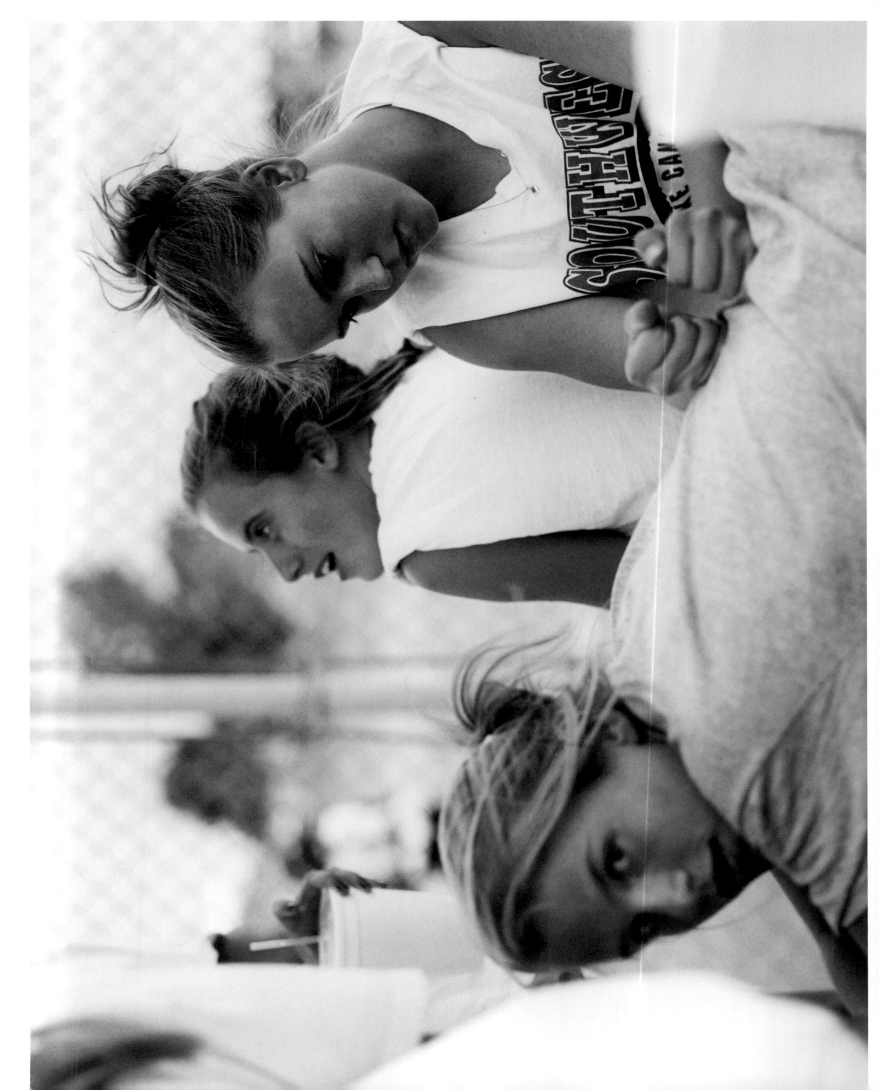

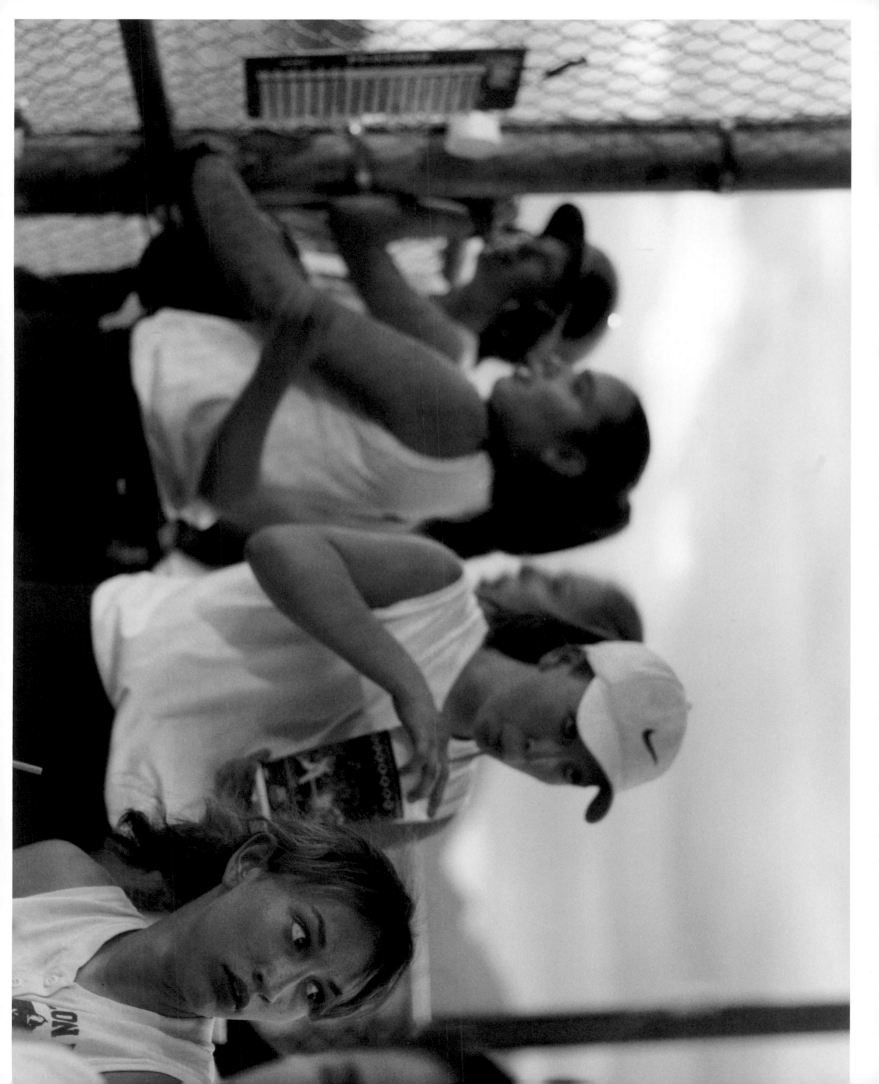

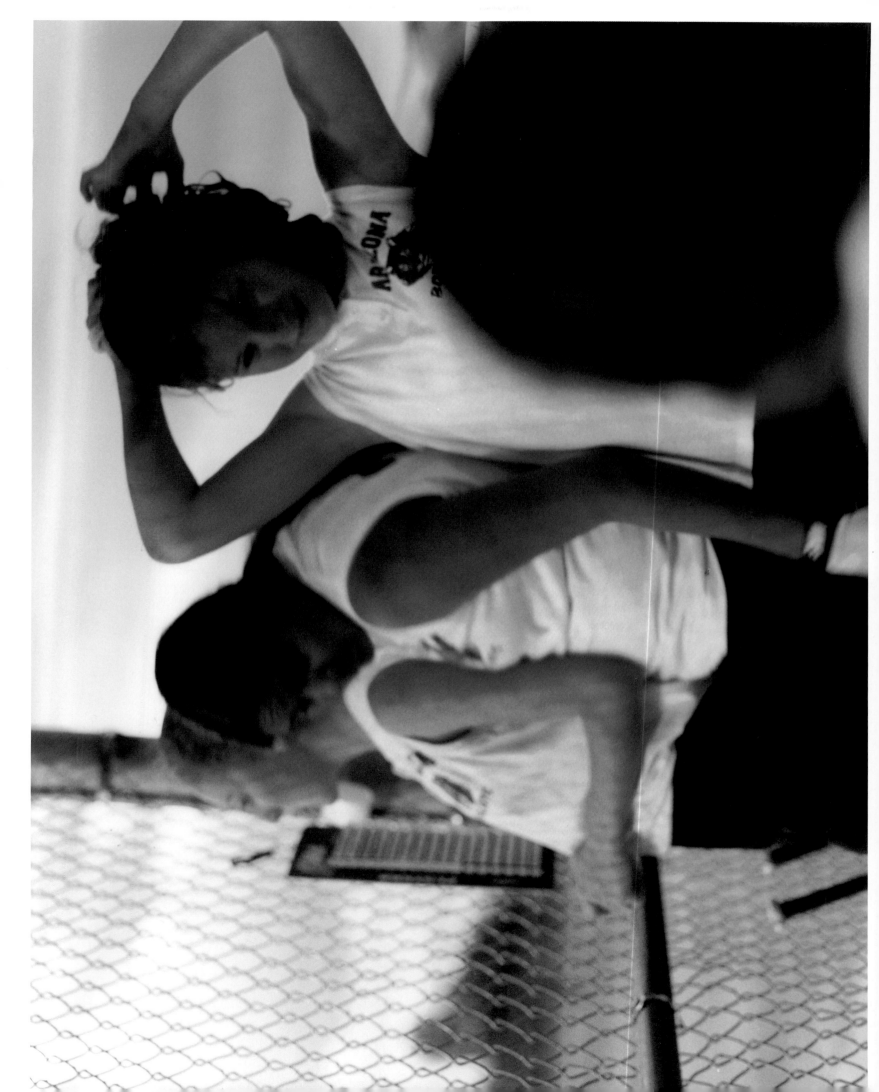

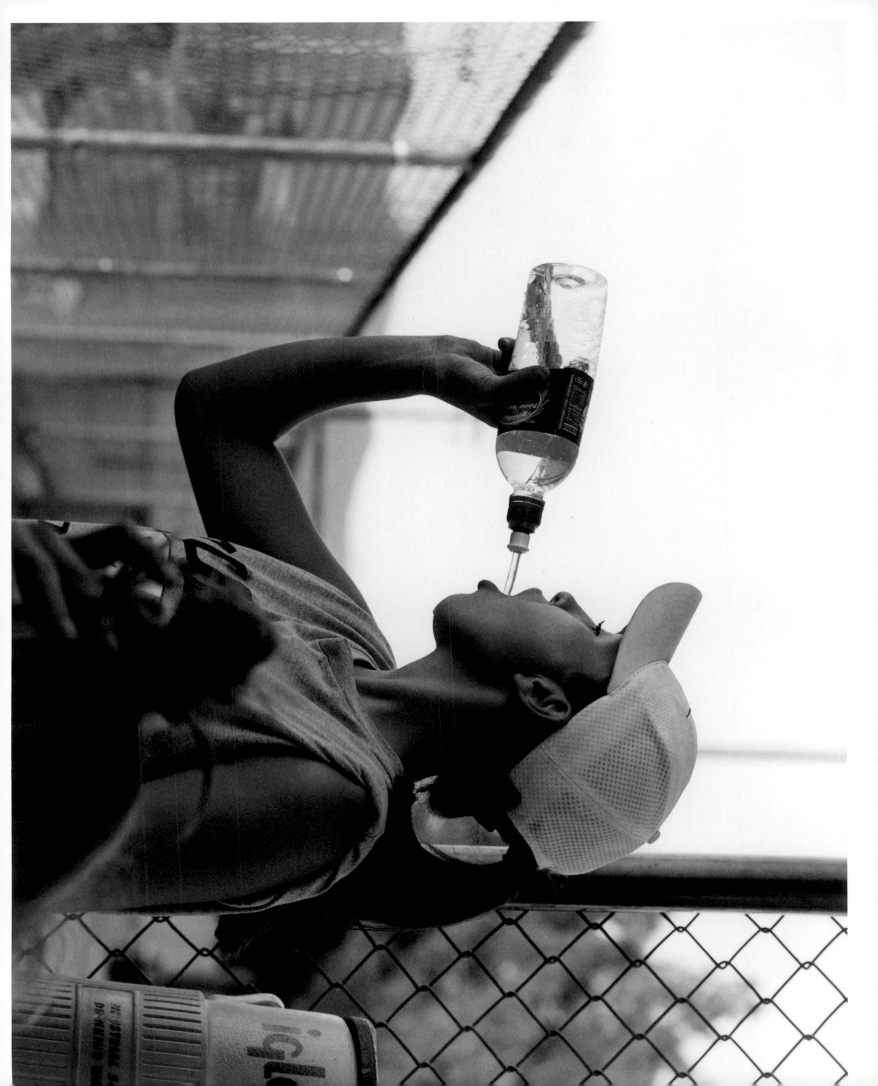

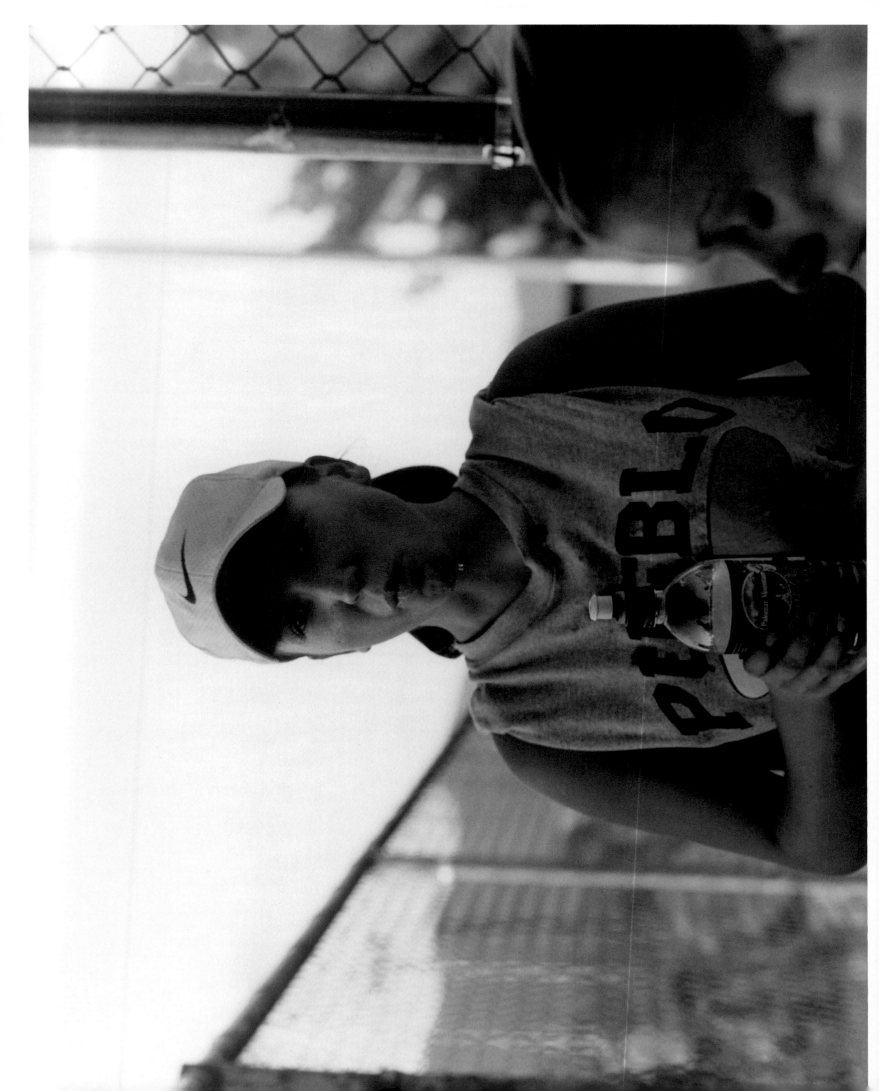

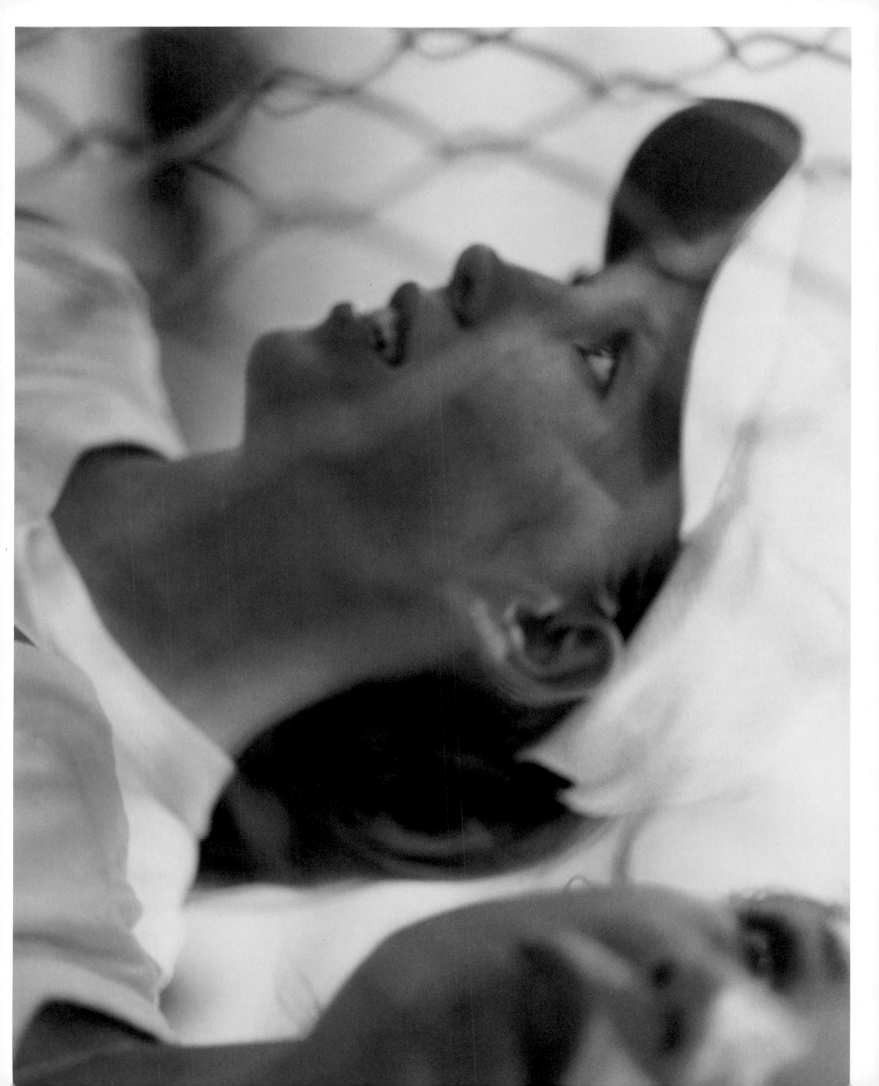

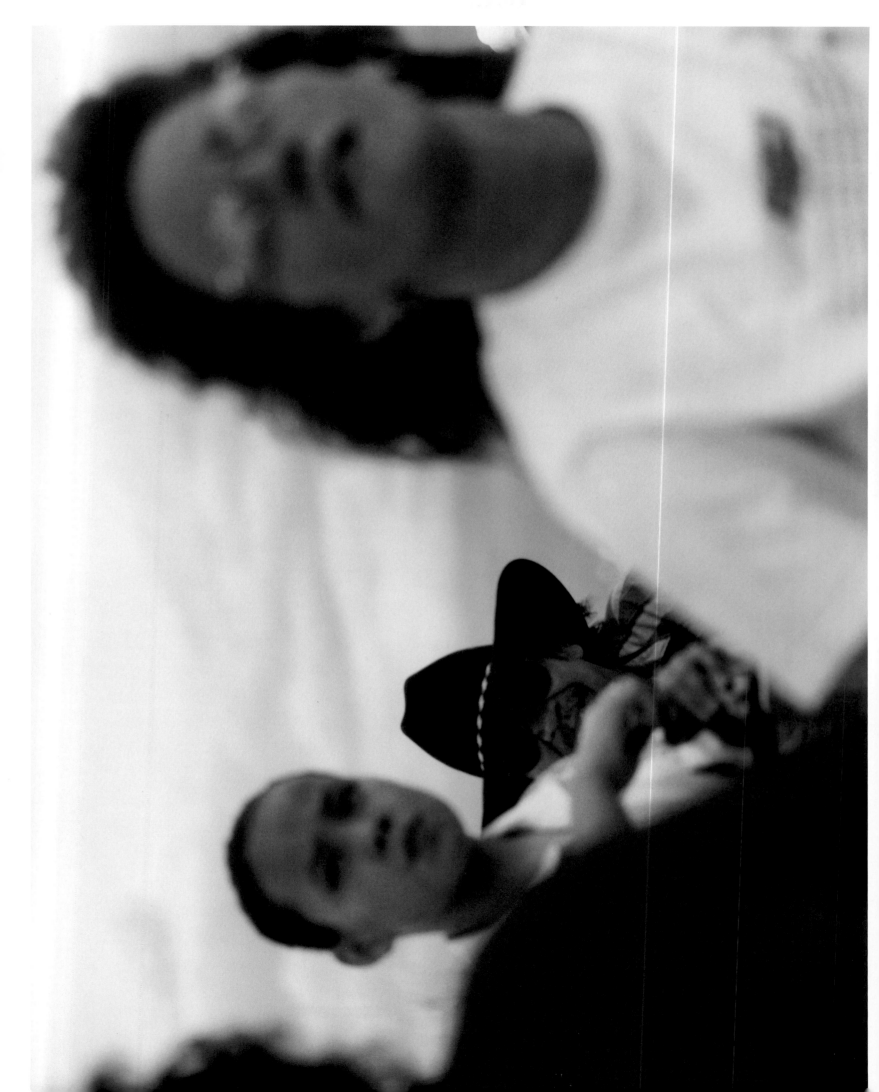

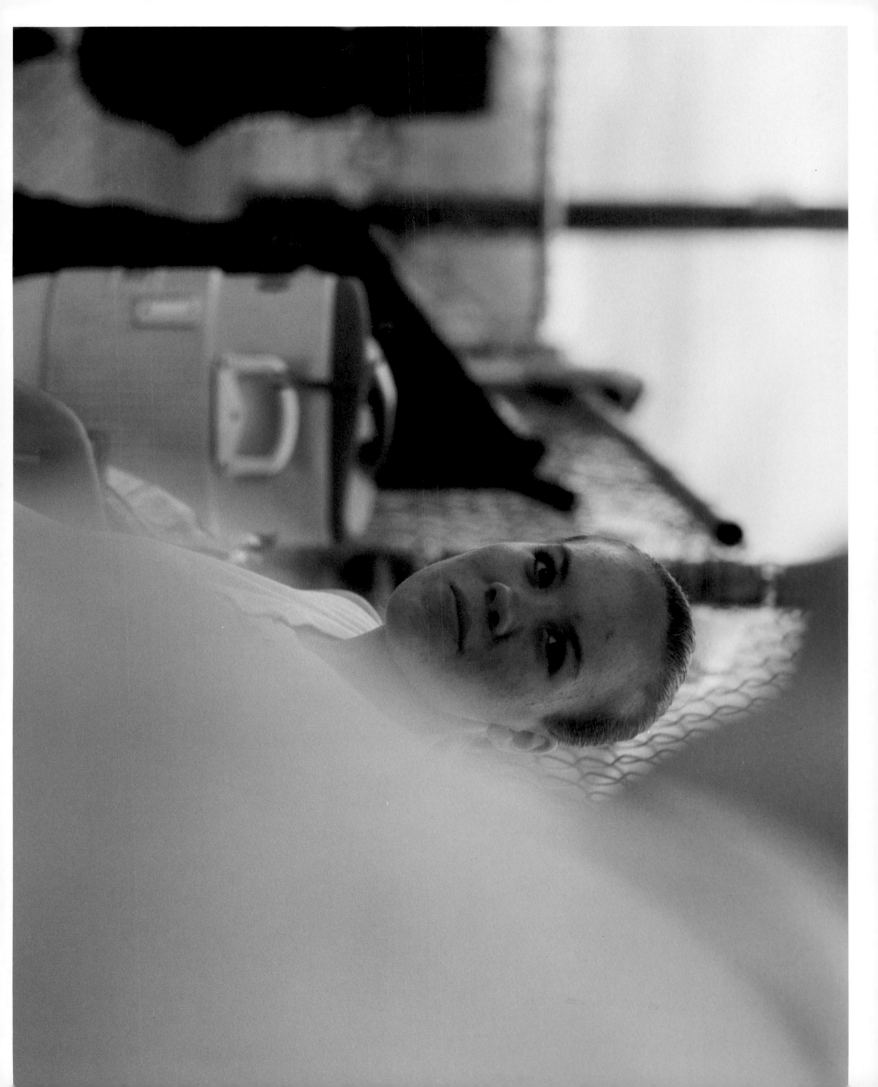

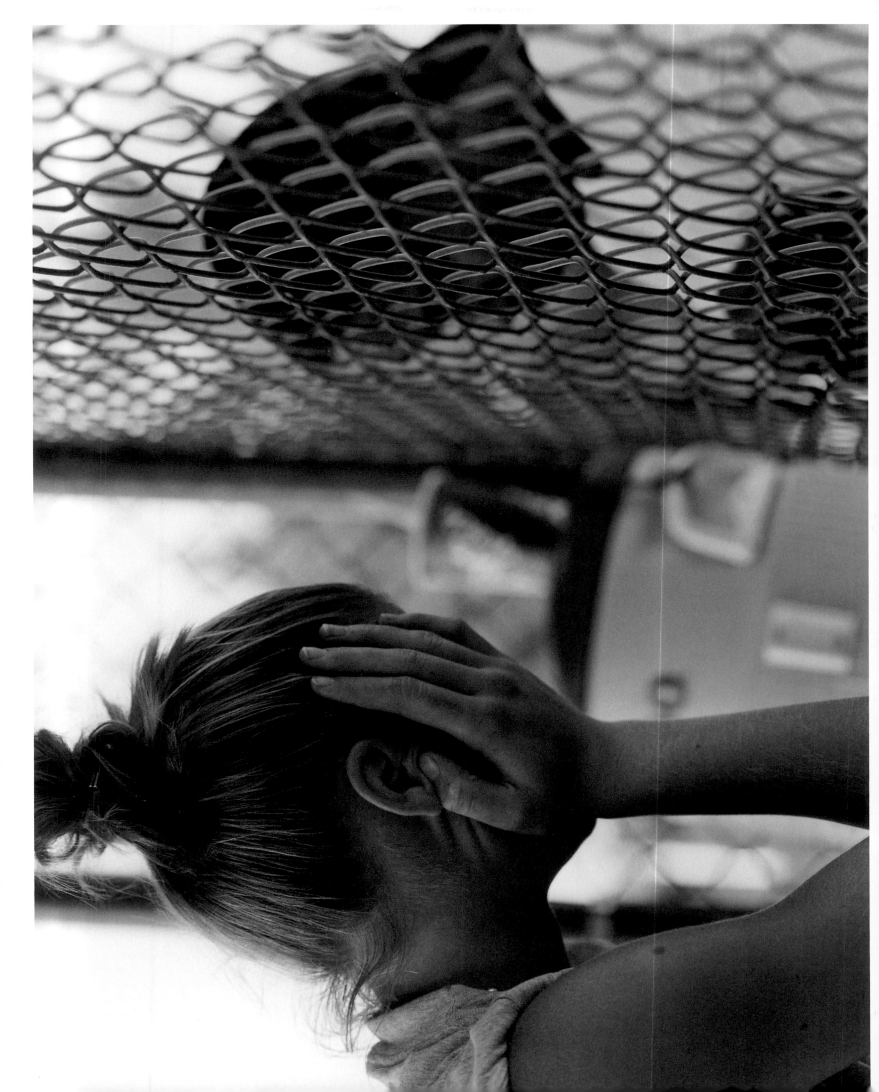

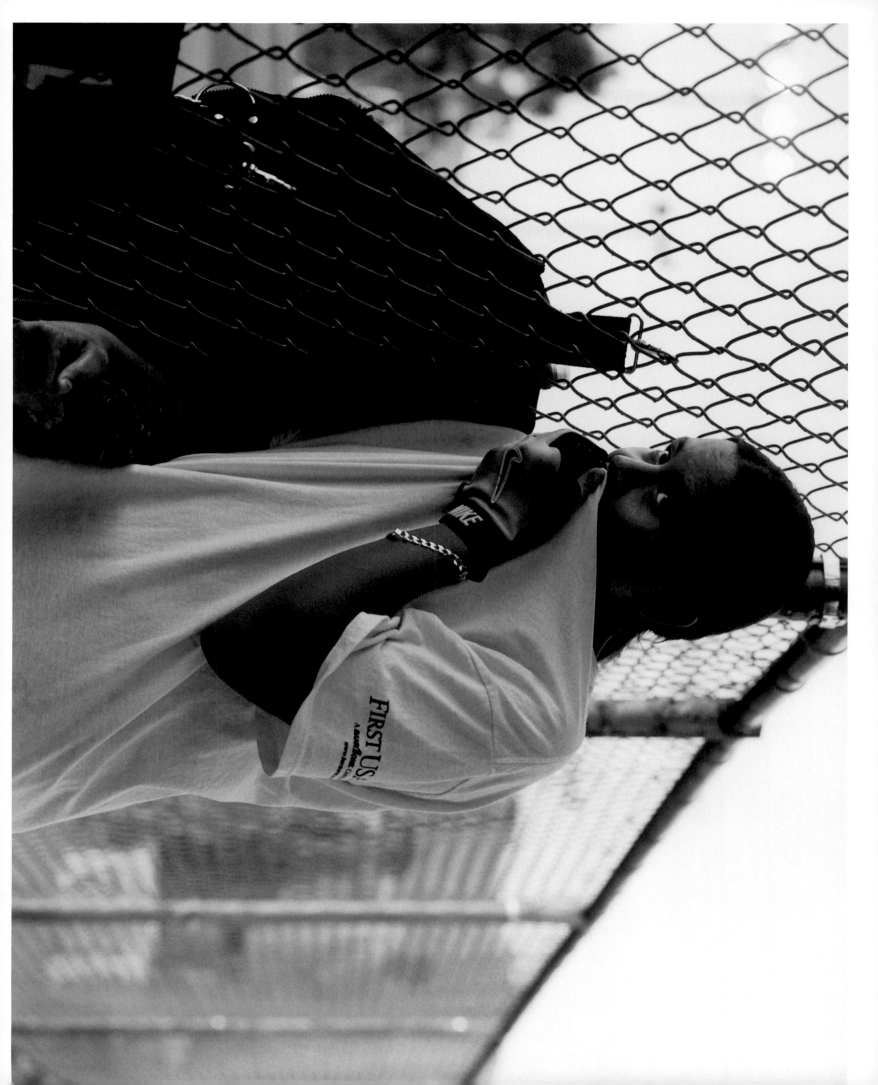

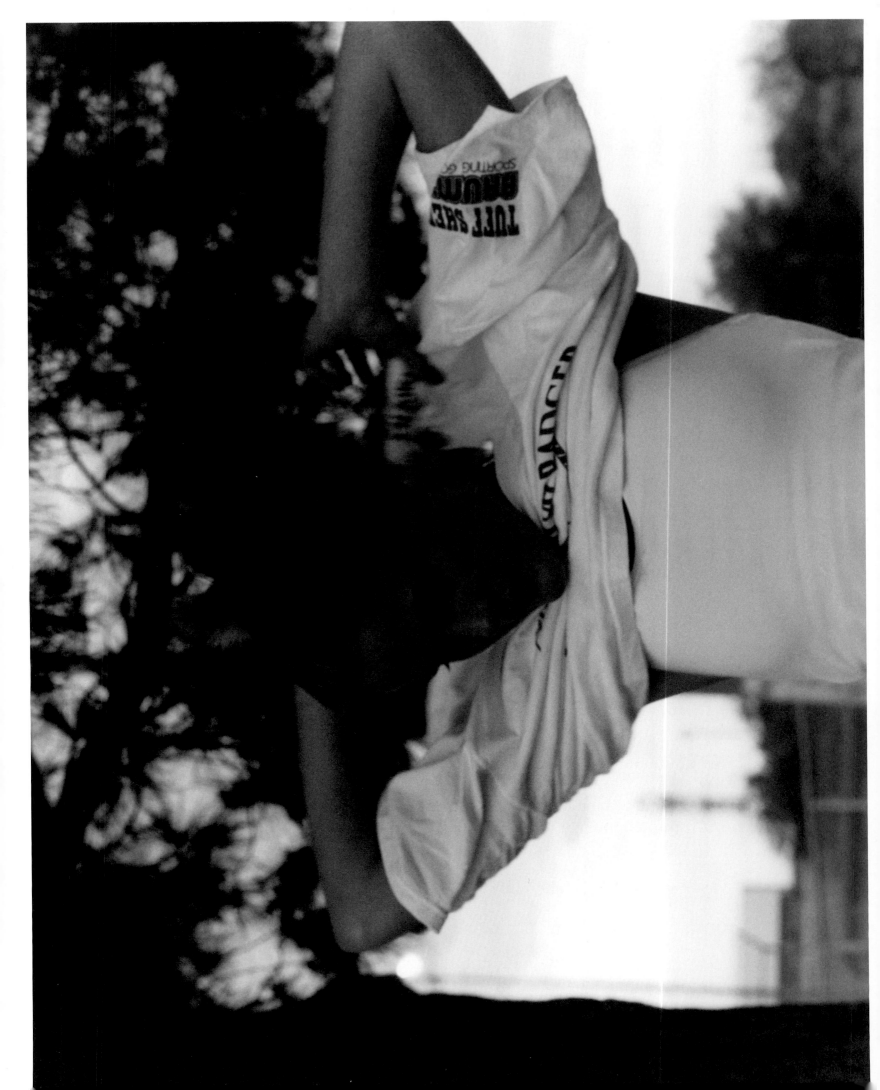

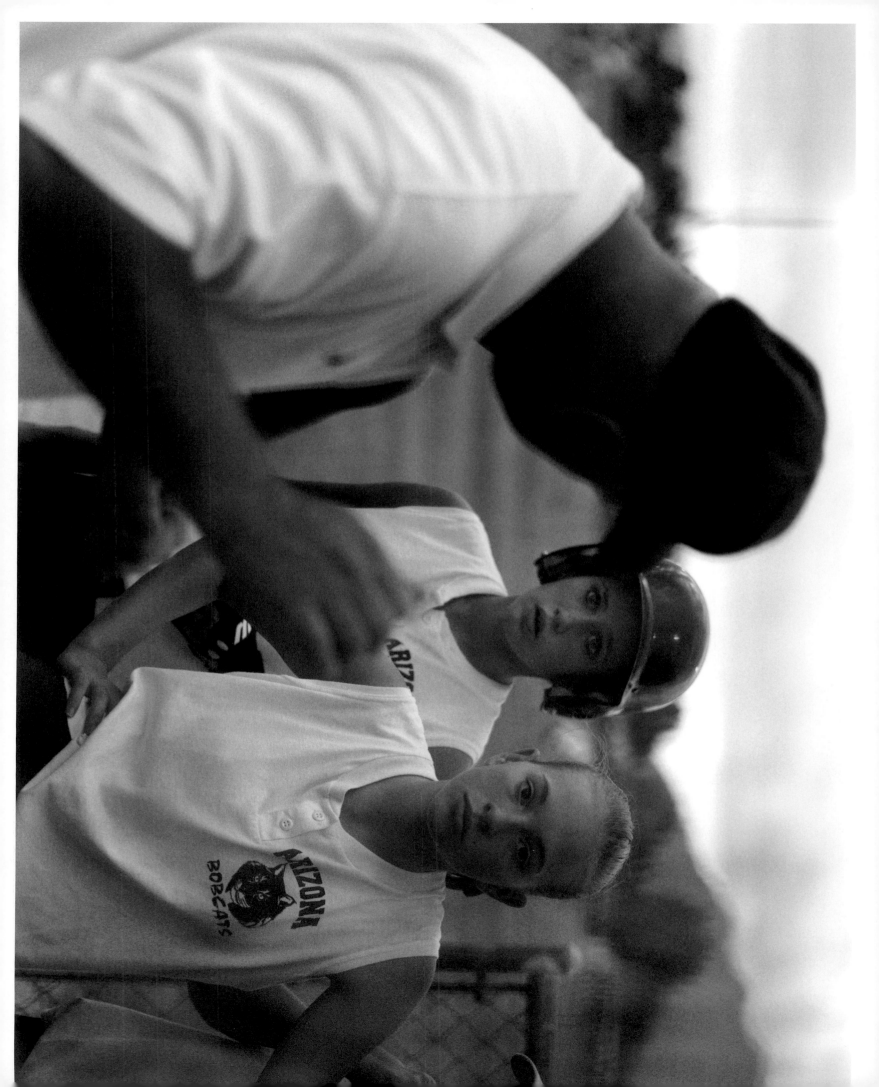

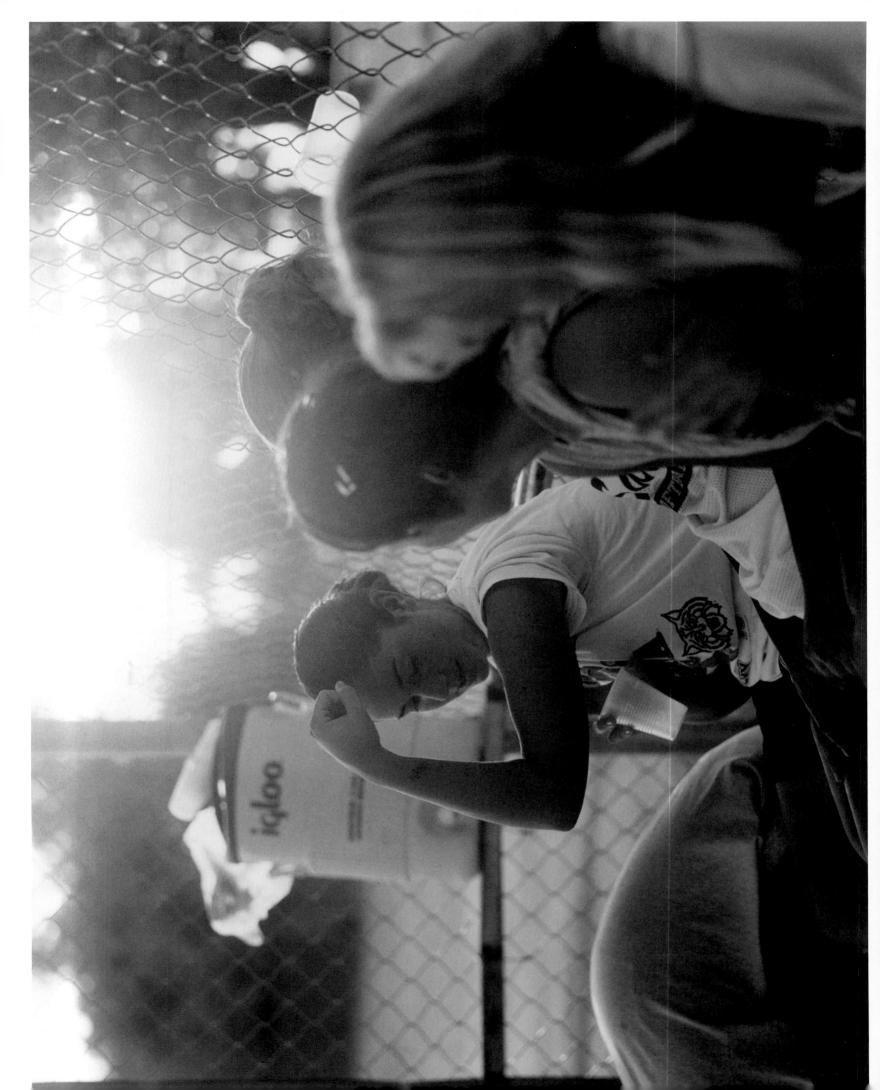

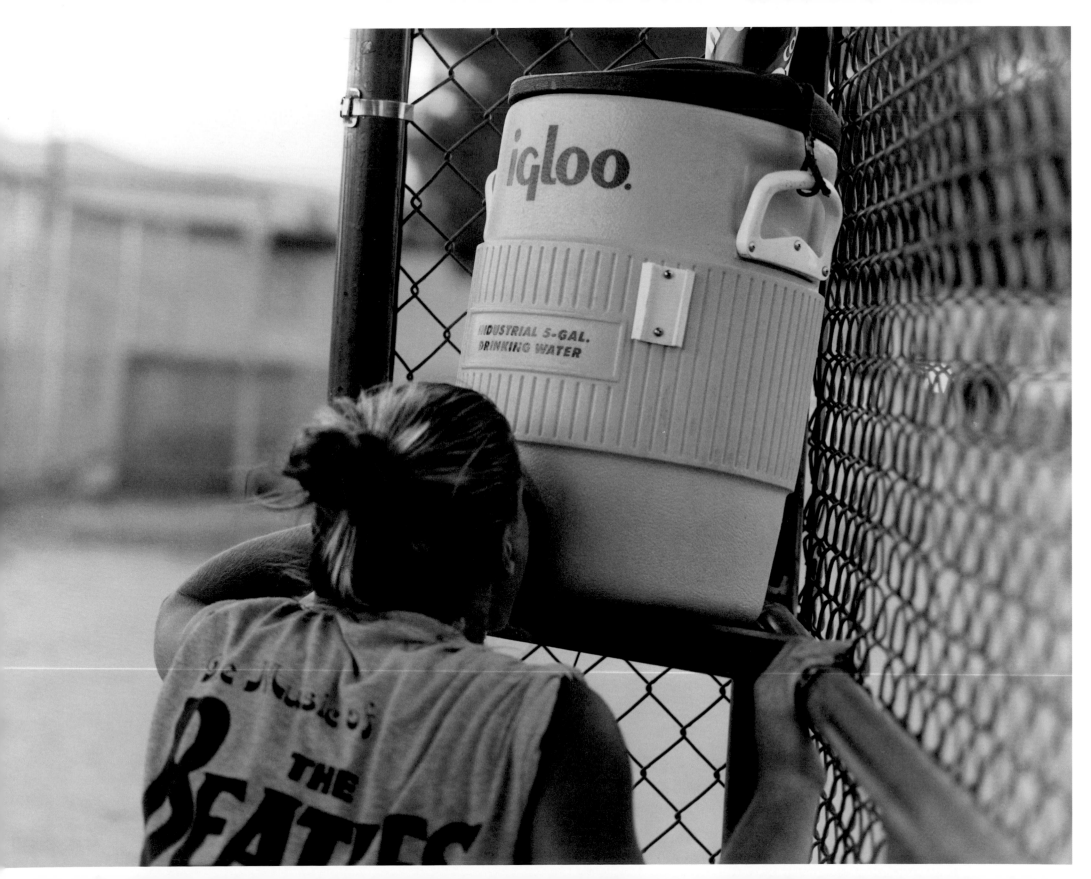

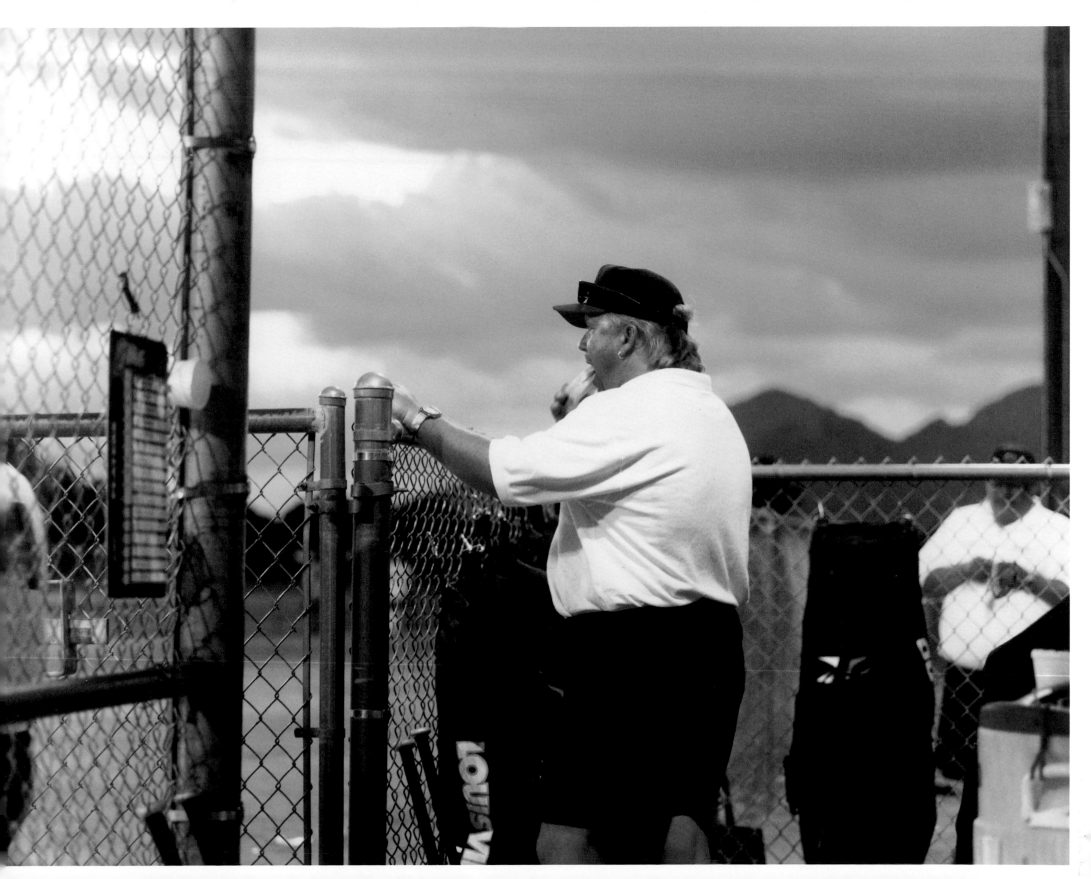

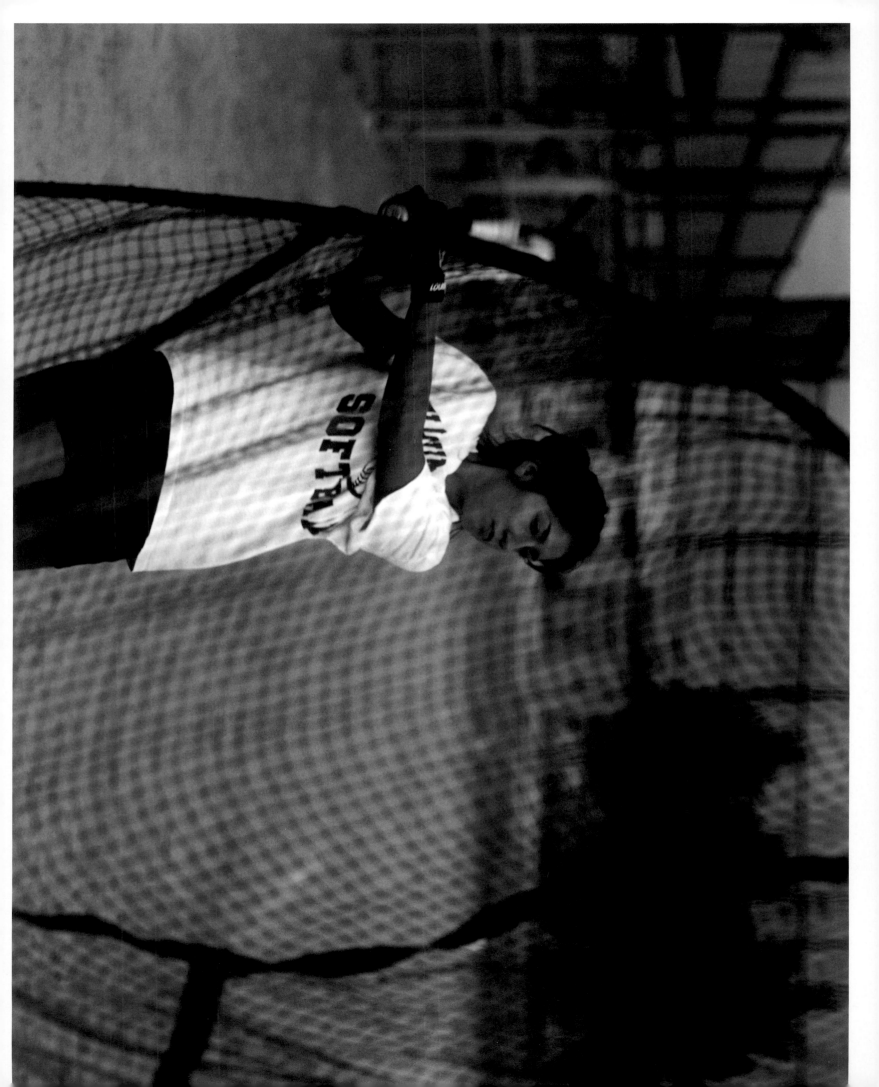

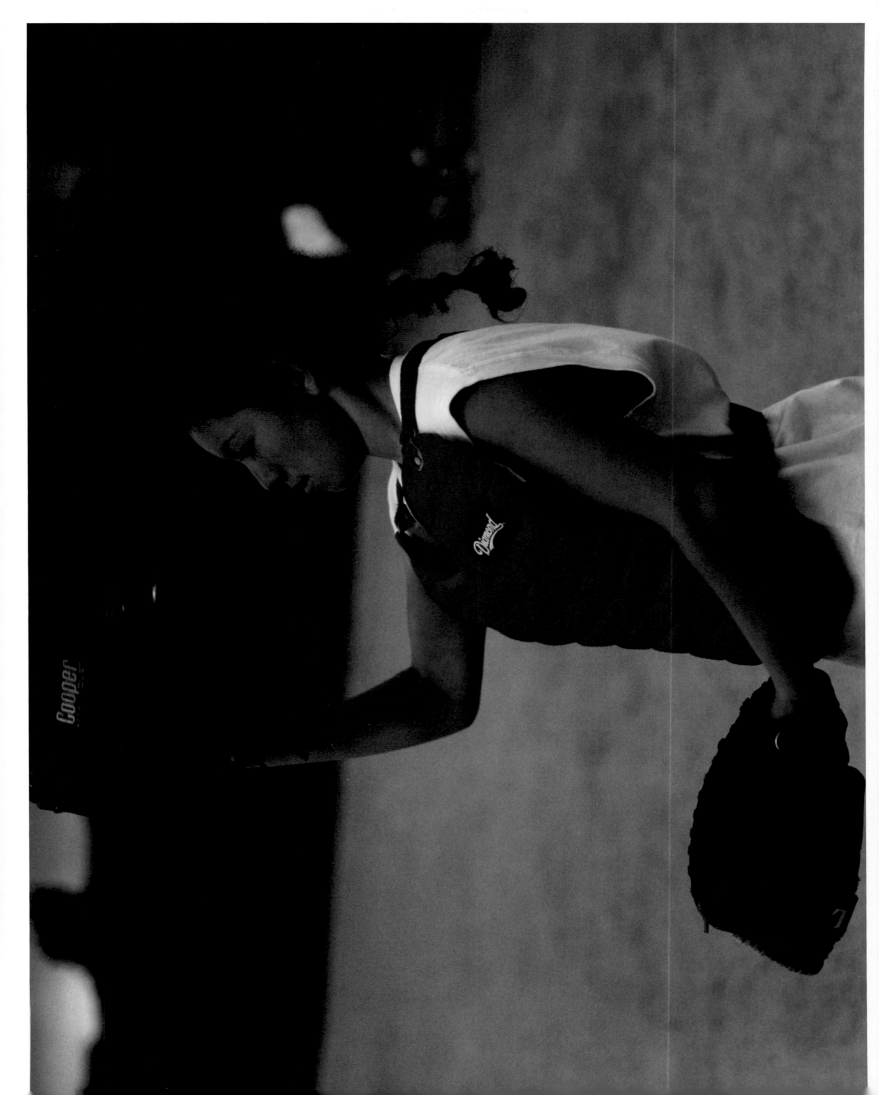

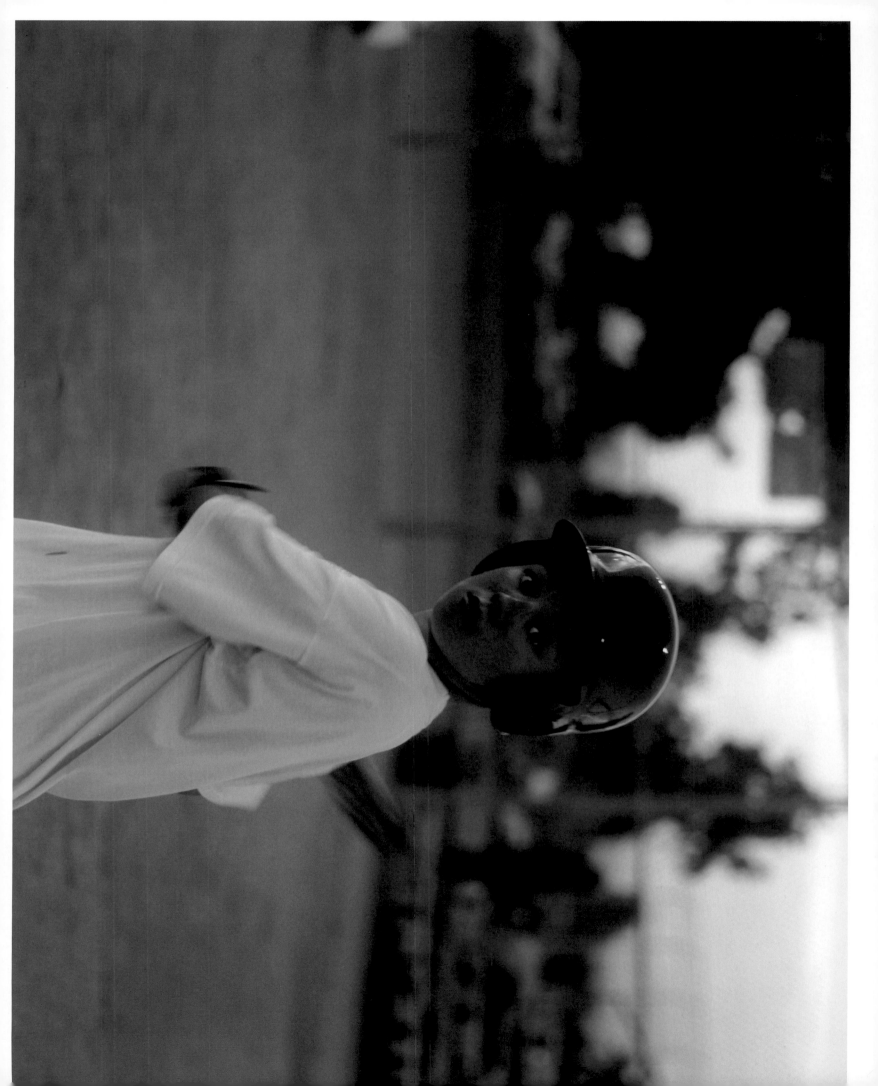

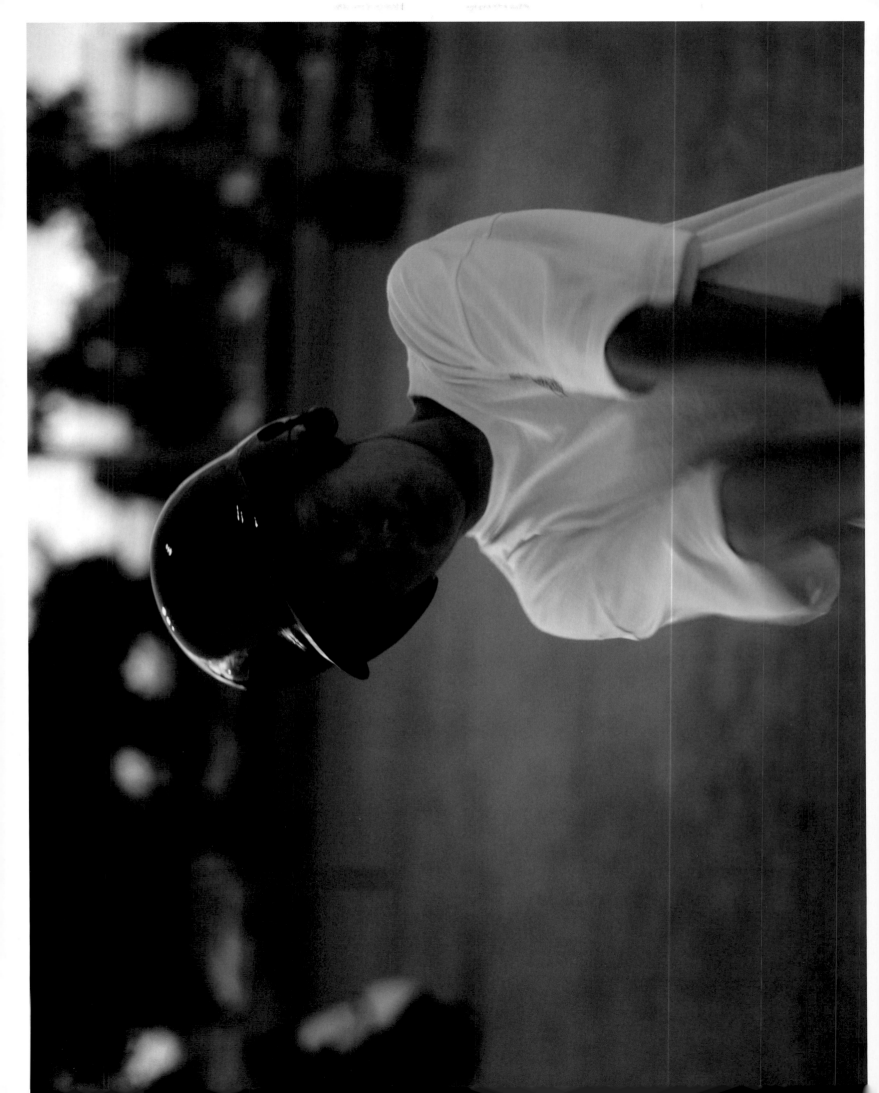

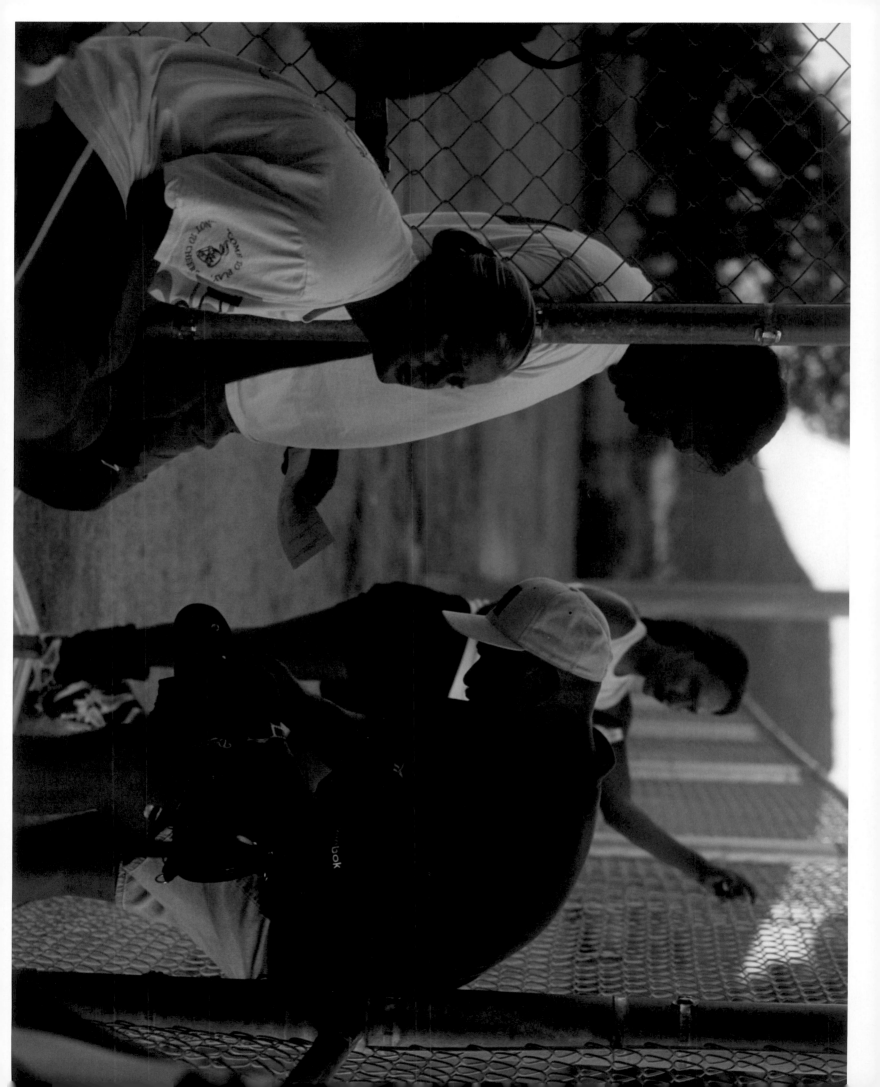

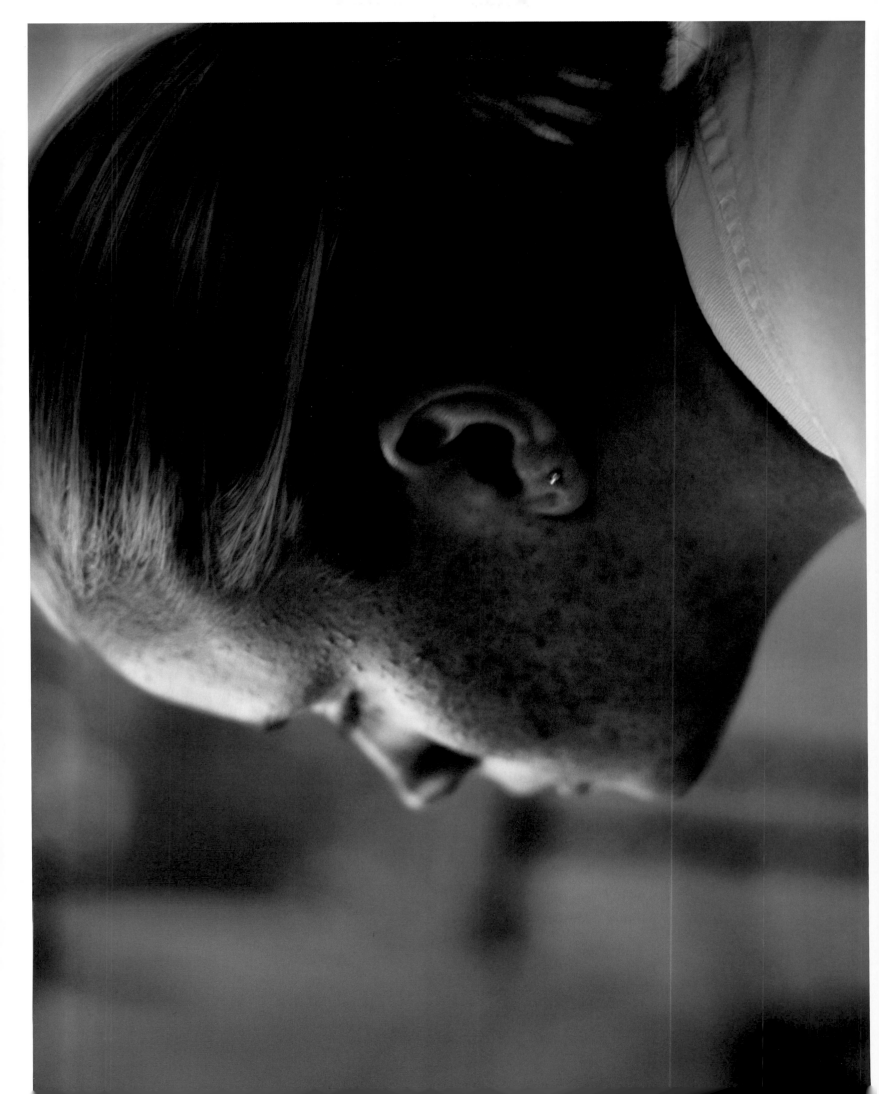

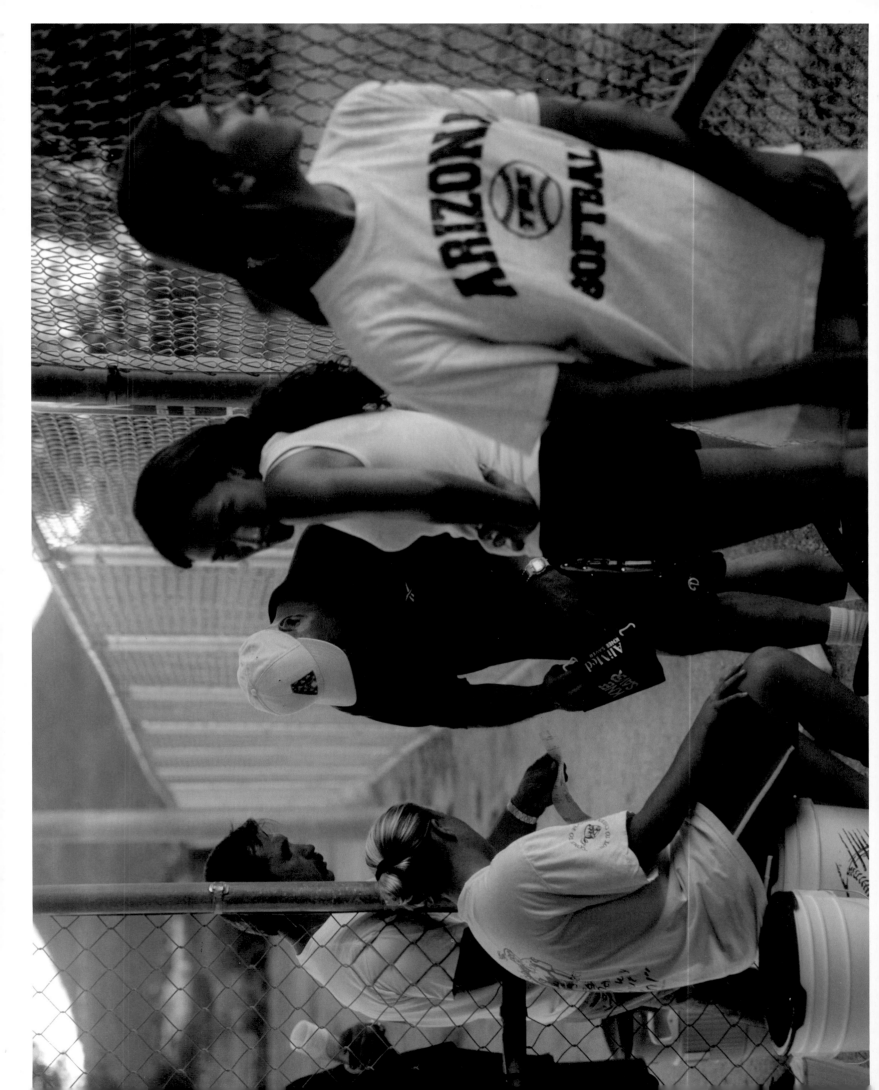

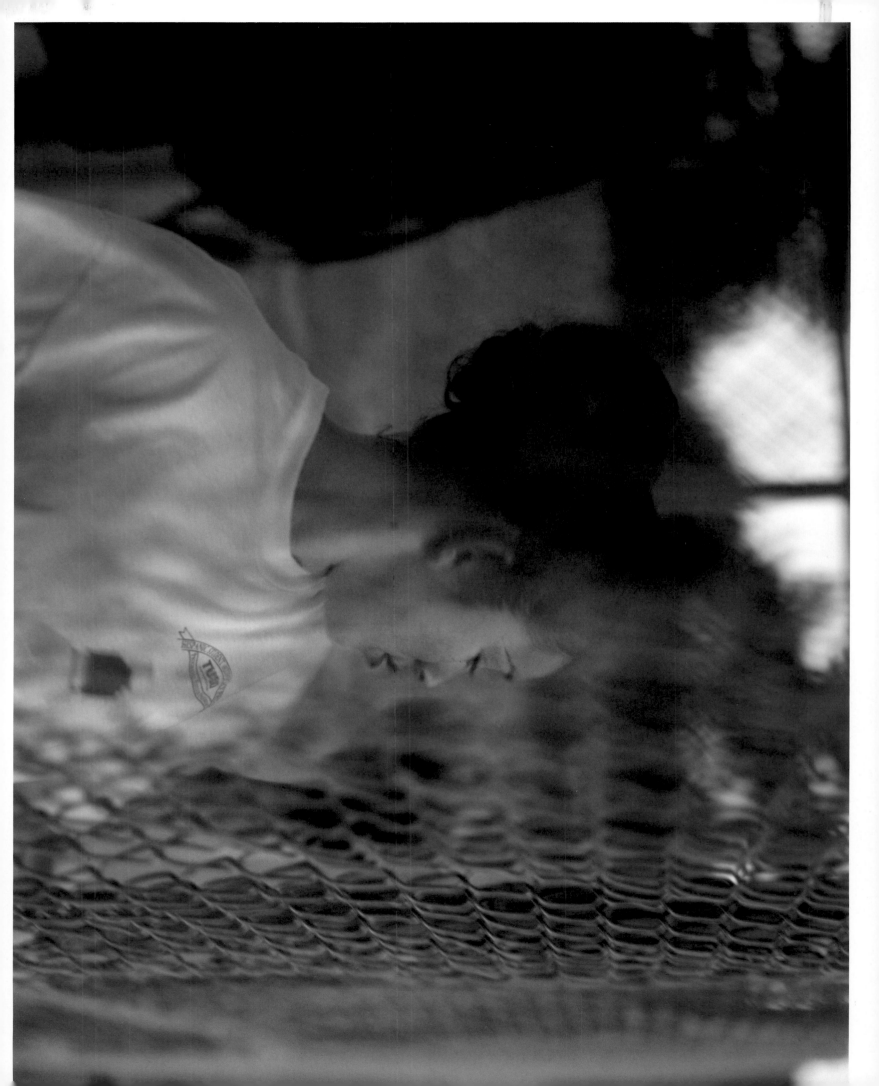

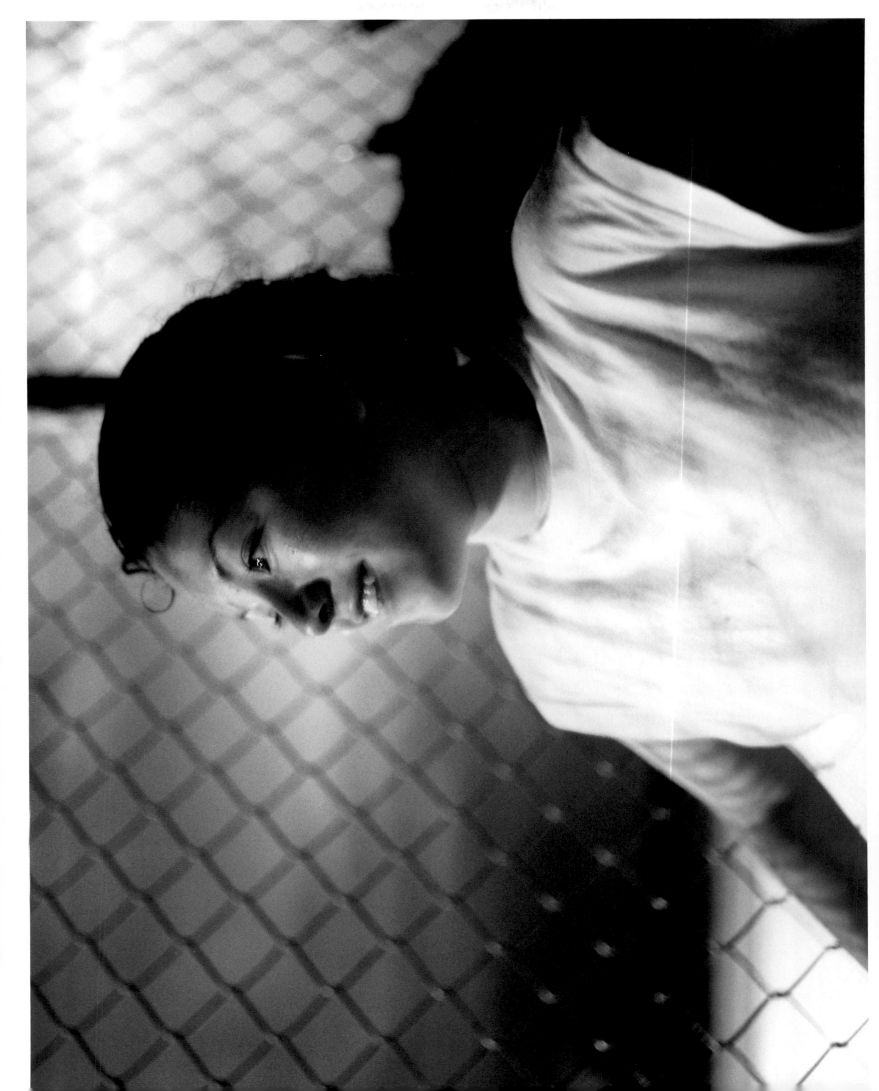

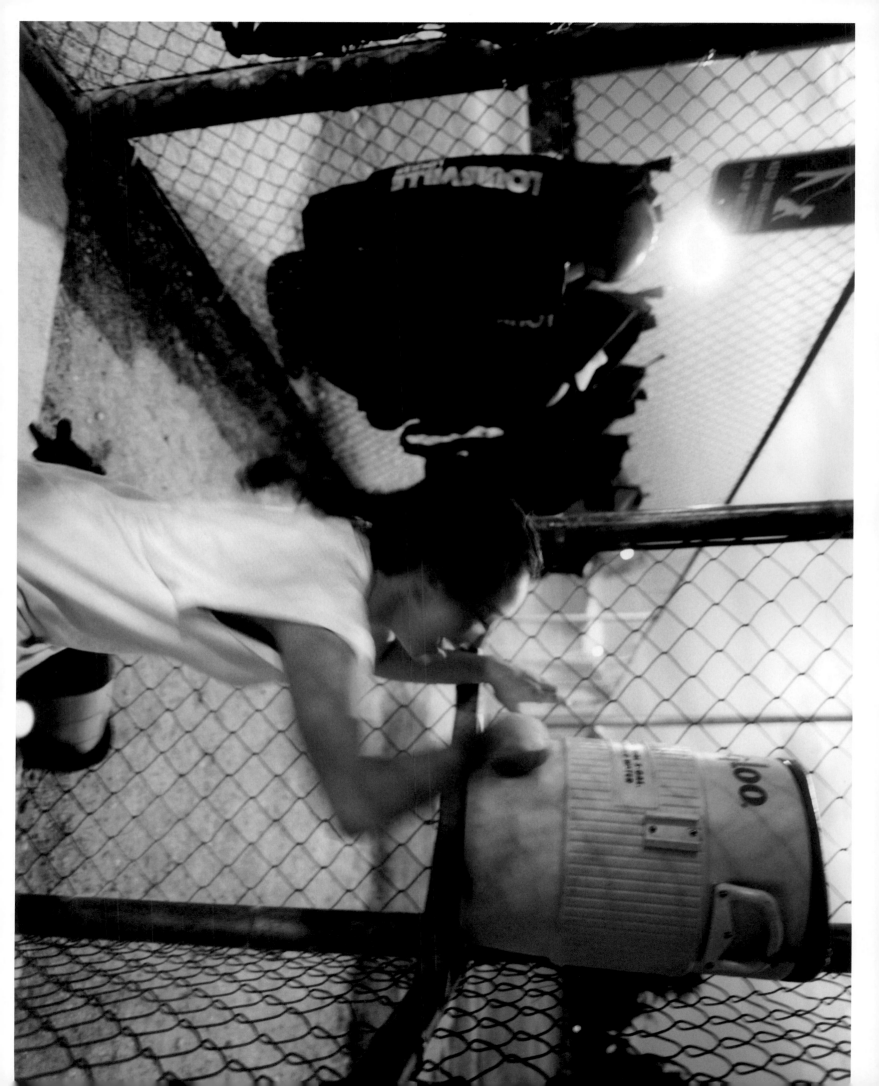

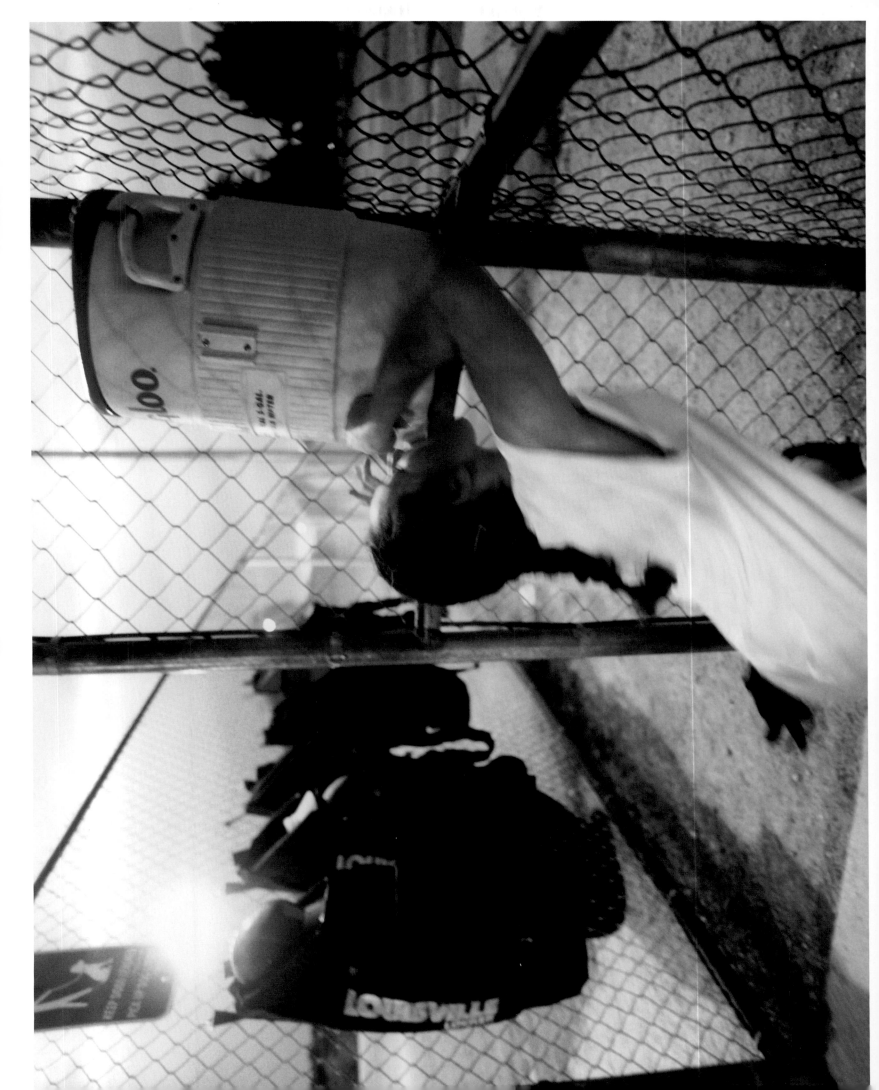

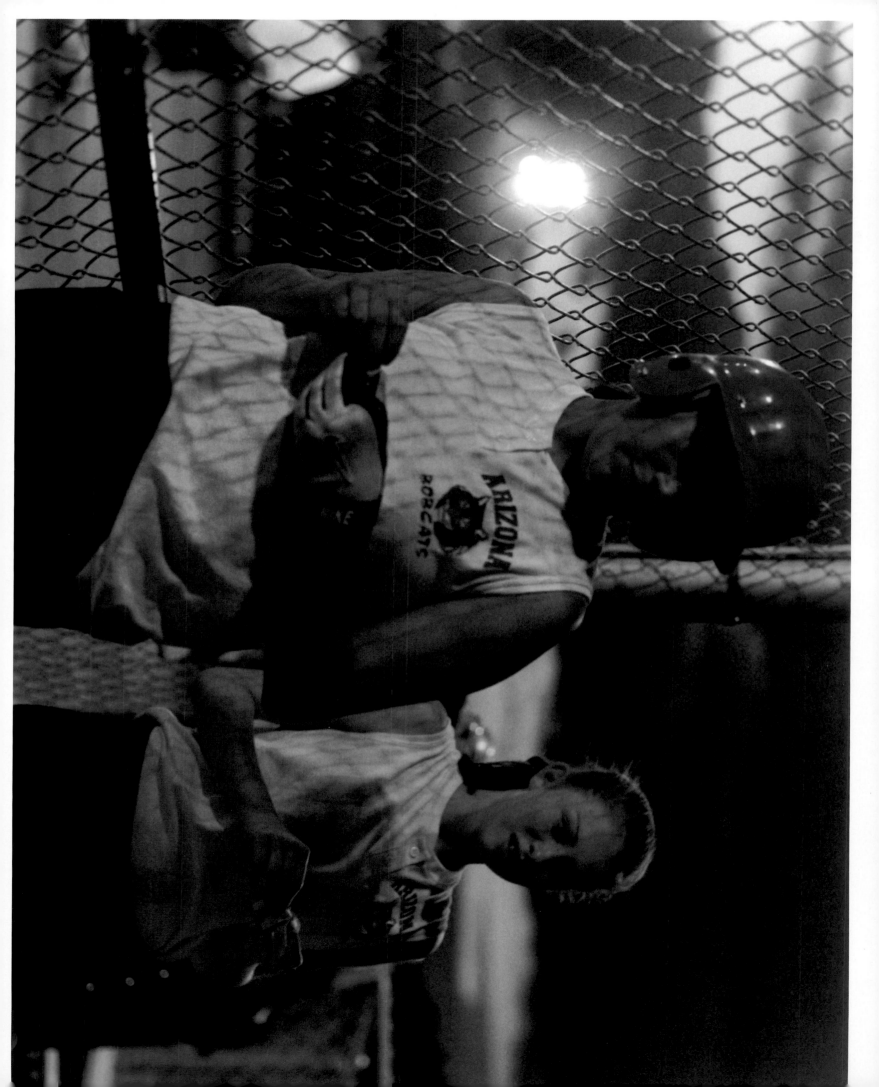

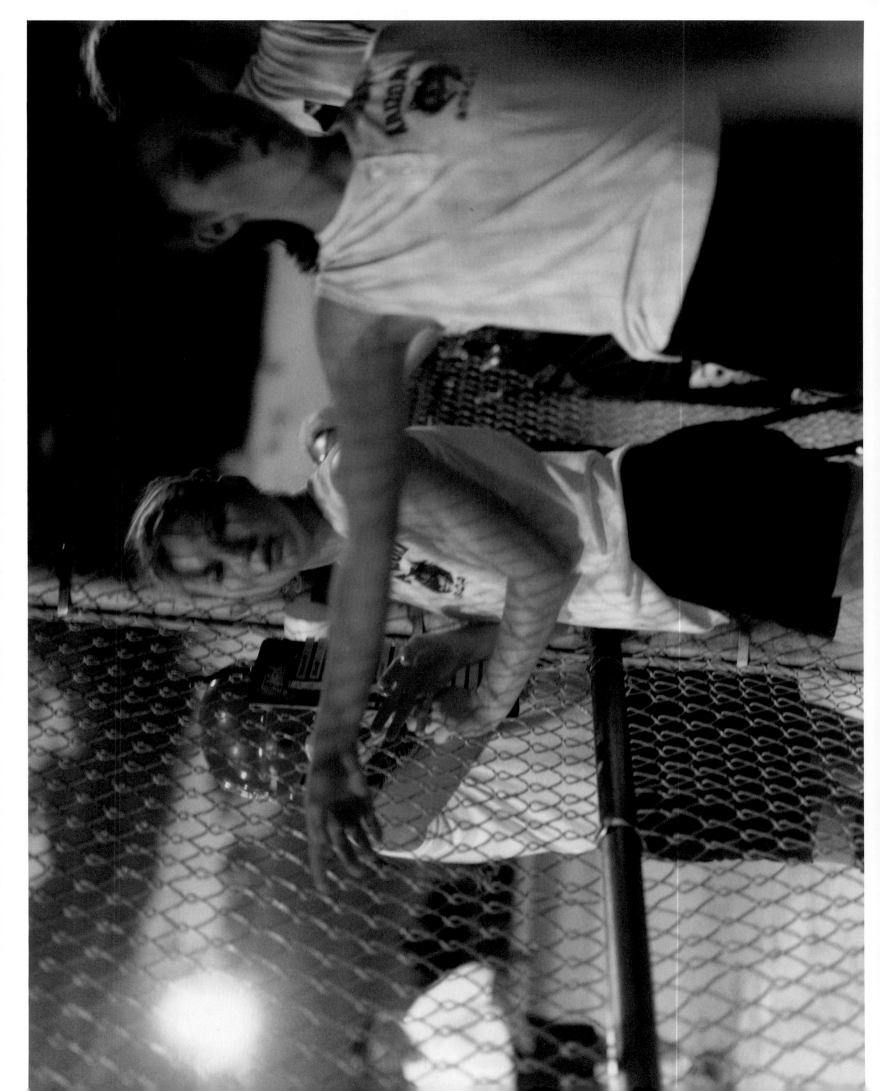

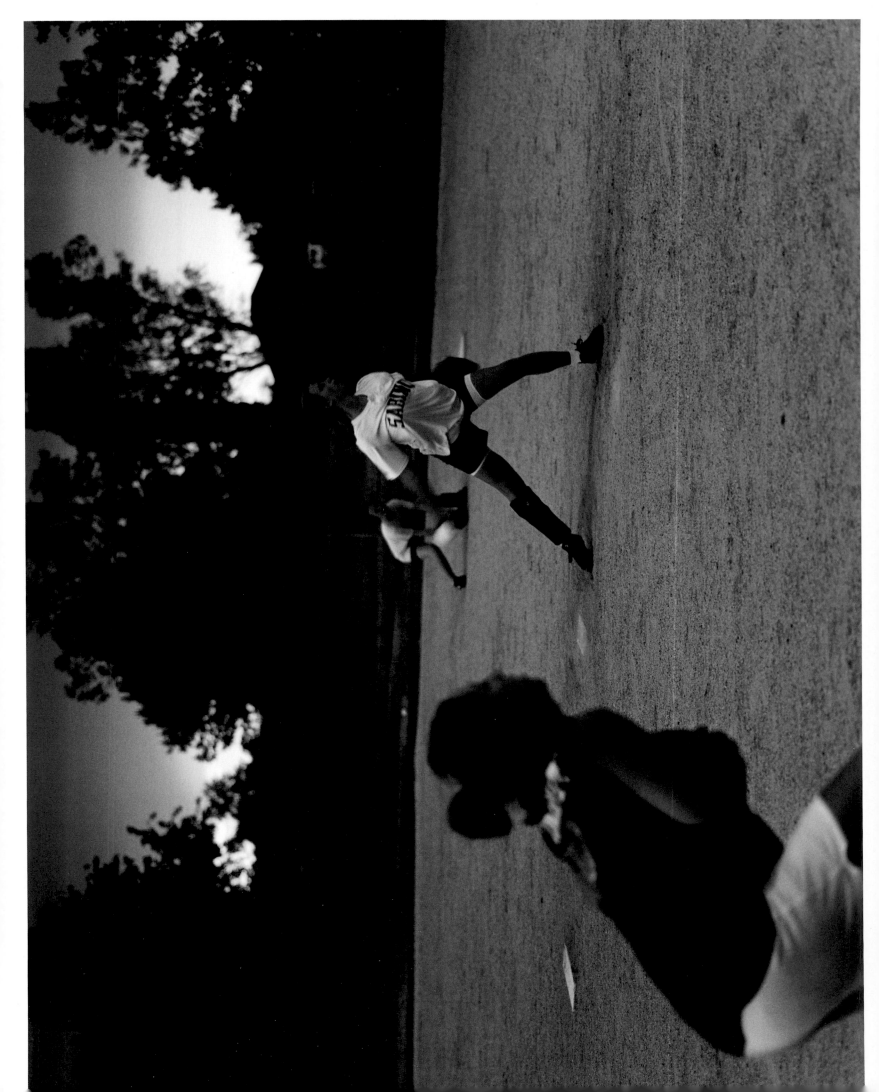

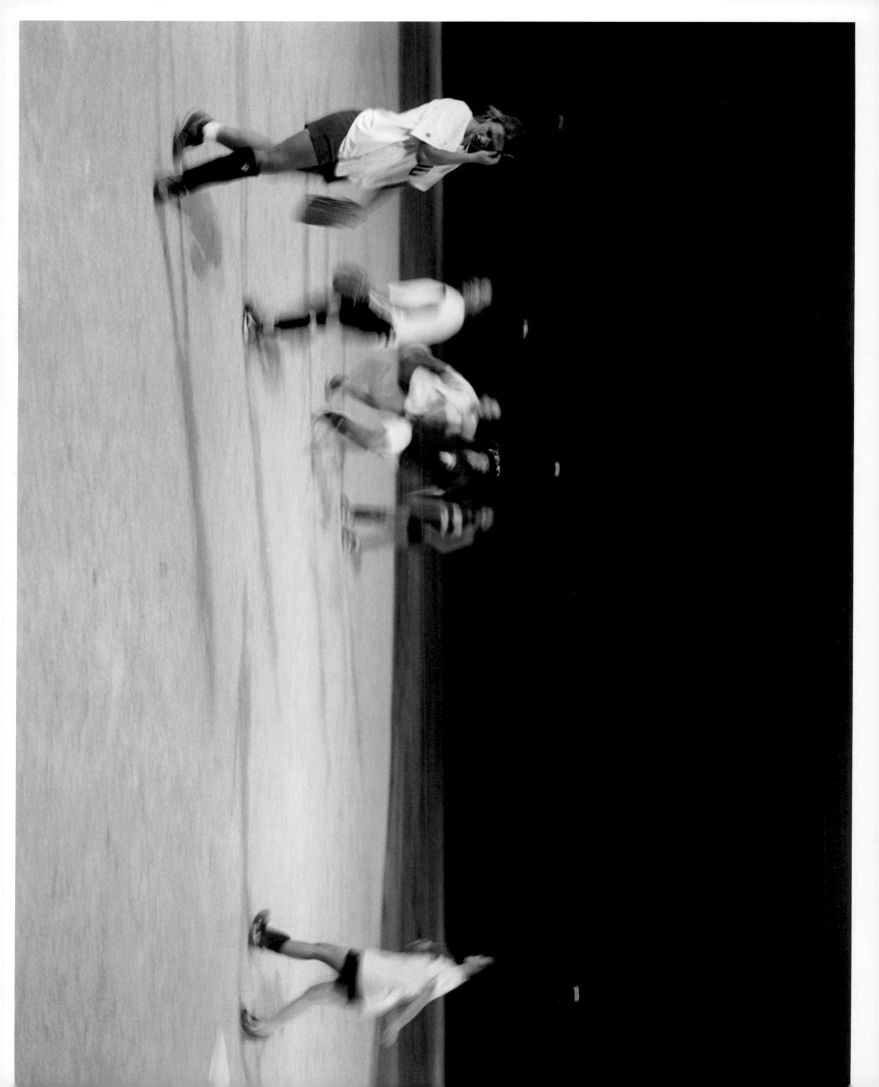

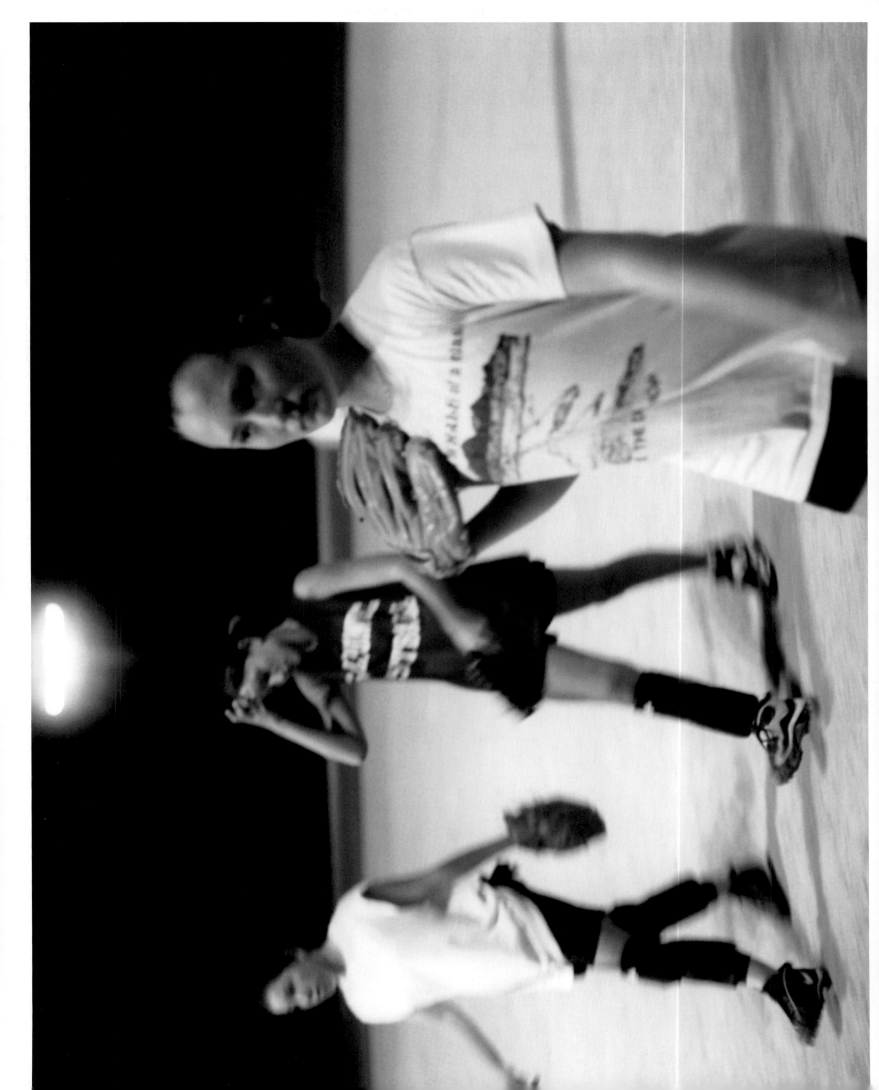

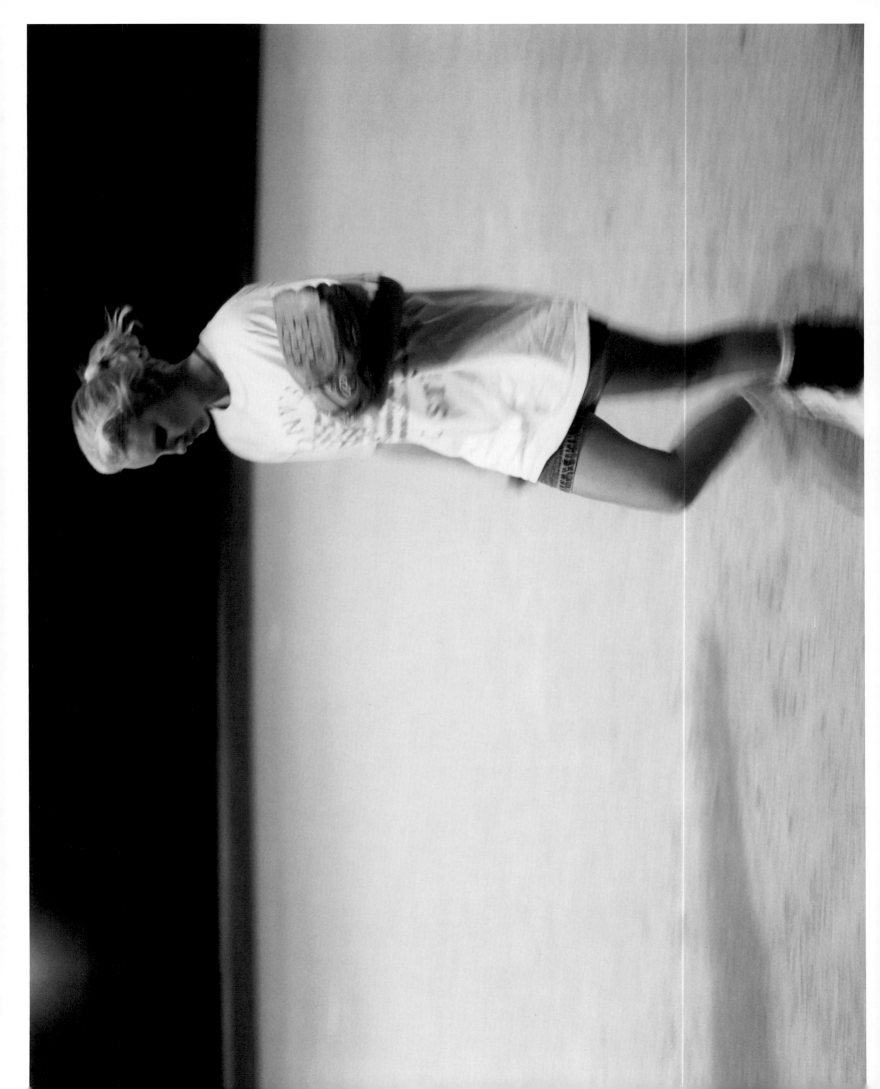

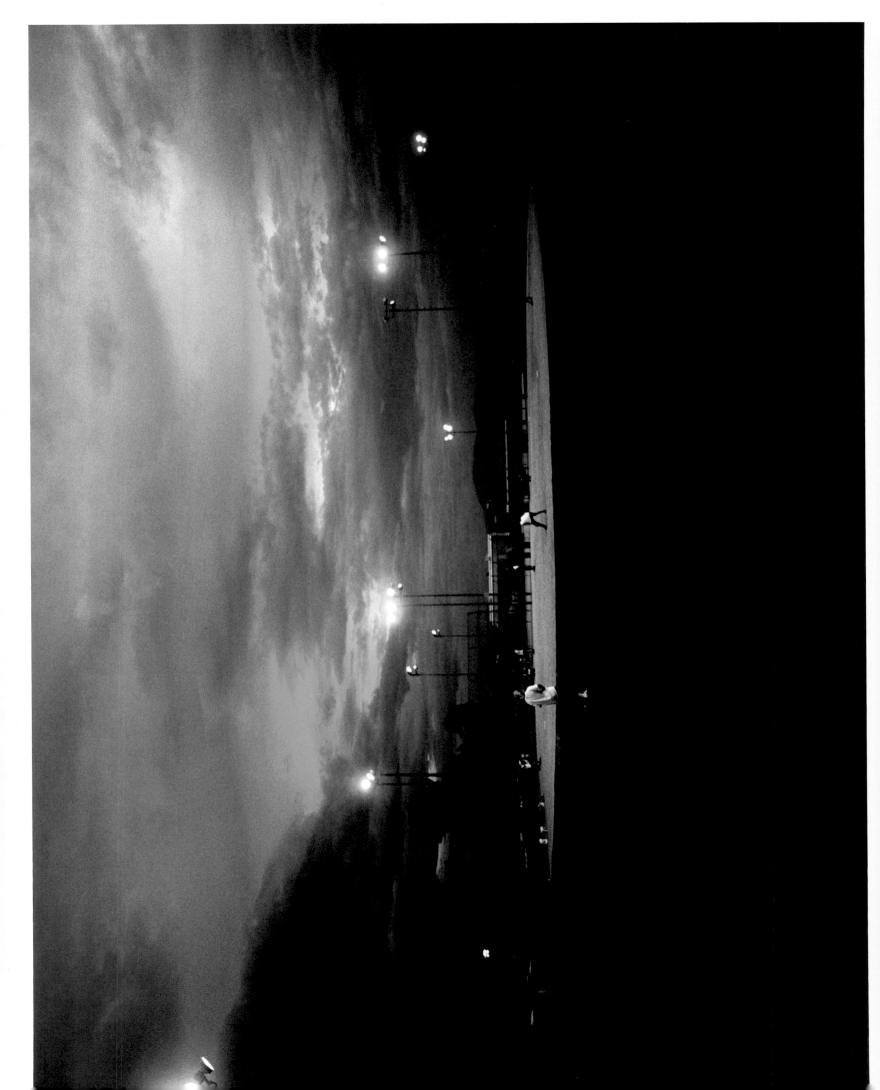

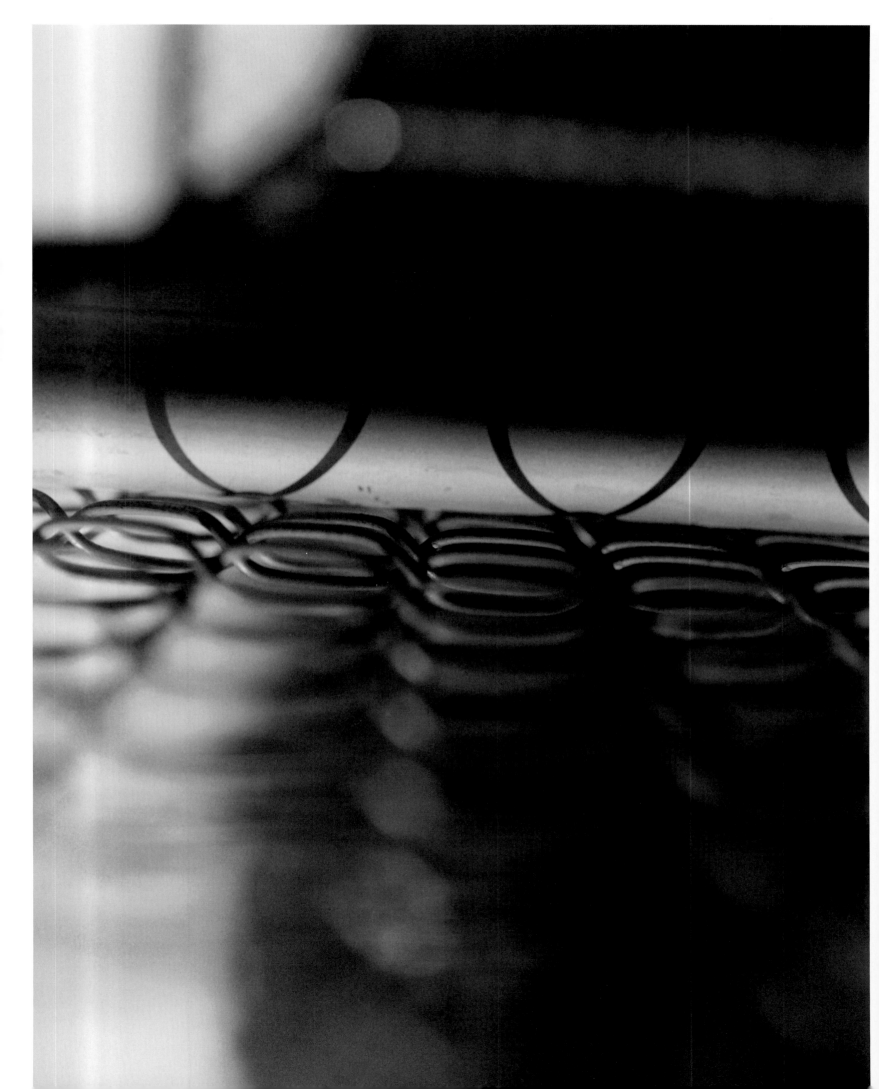

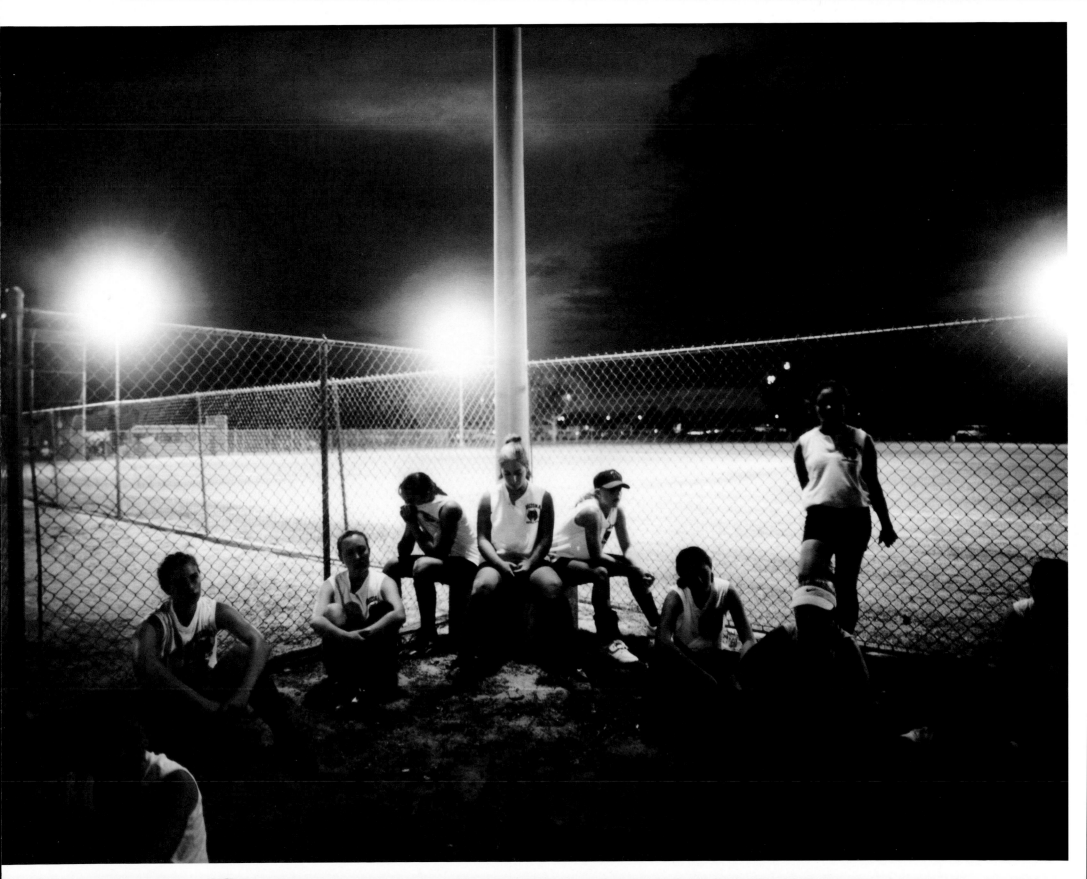

With a very special thank you to my parents, Martin and Doris Payson, this book is dedicated to the memory of Esther Aboodi.

ACKNOWLEDGMENTS

Gail Adler, Chante Anderson, Valerie Arkos, The Arizona Bobcats, The Arizona Inn, ASA Softball, Bennett Ashley, Greg Baker, Nick Bandy, Franya Barnett, James Bender, Jeremy Bender, Jon Bendis, Michael Bent, Jon Berkowitz, Jay & Rita Berman, Donna Bojarsky, Dan Bornstein, Bodo Niemann Gallery, Laurel Bowman, Cass Brady, Marshall & Marilyn Butler, Celia Calicstro, Chama Calicstro, Hugh Callahan, Canyon Ranch, Dean Caroll, David Castleberry, The Center for Creative Photography, Leo Chapman, Click Models, Coach Ed, Craig Cohen, Kim Cooper, Bob Daly, Brian Danels, Kay Delaney, Lou Dibella, Dr. Steven Dopkin, Les Edwards, Marcy Epstein, Paula Ewin, Dan Fellman, Lisa Finerman, Linda Fiorentino, Kenneth Fink, Martin Flores, Rene Fotouhi, Mark Friedman, Rick Friedman, Steve Friedman, Fujifilm, Dr. Henry Louis Gates Jr., Nicki Glasser, Dean Goldberg, Stu Goldin, Doris Kearns Goodwin, Robert & Maya Gottlieb, Scott Greenstein, Michael Griffith, Ann Hartmayer, Billy Hecker, Dean Hecker, Katie Hess, Paul Hess, David Himelfarb, Lowell Hussey, Jodi Jacobs, Steven Jacobs, Eric Jakobs, Jeffrey's World of Travel, Lillian Johnson, Robert Johnson, Peter C. Jones, Vial Jones, Myron Kandel, Ken-Mar Camera, David Kekst, Gershon Kekst, Karen Kelleher, Kennedy Boesky Photographs, Caroline Kerrigan, Adam Kluger, Kodak Film, Robbie Koeppel, Jim Krass, Tzvika Kraut, Ira Krebs, The Krespin family, Ken Lieberman, Larry Lieberman, The Los Angeles County Museum of Art, Louisville Slugger, Lynn Marcus, Scott Markowitz, Linda McCartney, Judy McGrath, Rick McKay, MTV Networks, The Muffins Shop, Mark Nathanson, National Airlines, Kyle Nemet, Nike, Nova O'Brien, Marko Ogland, The Ohio State University Department of Photography, 1-800 Laundry, Karin Payson, Leslie Payson, Pentax, Hayley Petrook, Edward Polsky, powerHouse Books, Daniel Power, Mitch Pozez, Paul Pyon, Brett Rabbach, Jan Rafferty, Lisa Rogell, Sara Rosen, Benjamin Rosenfield, Simon Rosenfield, Daniel Rosenfield, Richard Roth, Einat Rubin, Edward Russnow, Karen Sachman, The Safehouse, Carol & Mal Schwartz, Norman Siegal, Jon Sexton, Steak Shapiro, Ken Sherman, Michael Shore, Robert Sobieszek, Steven Soleymani, Southwest Airlines, Spectra Photo, Pamela Stenace, Adele Tarren, Brenda Taylor, Dave Thomas, Time Warner Cable, The Travis Thomas Gang, Tucson Parks & Recreation Department, Tucson Police Department, Steven Tyler, Sara Vallely, Doris Voigtländer, Eric Weeks, Hope Van Winkle, Pat Vargo, The Viewing Room, Steve & Mina Weiner, Eric Weiss, Julie Wilson, Tom Wilson, Don Wise, Keith Wortman, The Yaghoubi family, Dr. Anna Zagoloff, Adam Zion.

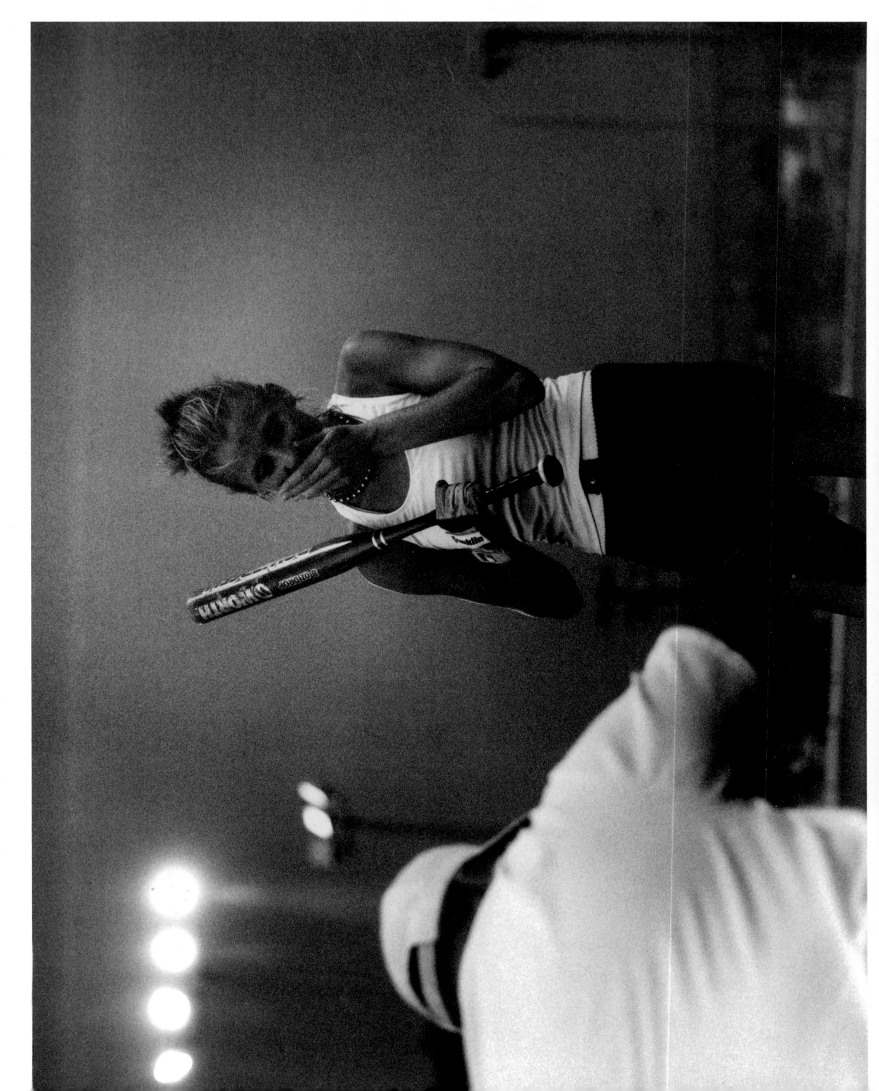

BOBCATS

Published in the United States by powerHouse Books,
a division of powerHouse Cultural Entertainment, Inc.
180 Varick Street, Suite 1302, New York, NY 10014-4606
telephone 212 604 9074, fax 212 366 5247
e-mail: bobcats@powerHouseBooks.com
web site: www.powerHouseBooks.com

First edition, 2002

Library of Congress Cataloging-in-Publication Data:

Payson, Eric.
 Bobcats / photographs by Eric Payson ; essay by Robert Sobieszek.
 p. cm.
 ISBN 1-57687-142-8
 1. Softball for women--Pictorial works. 2. Bobcats (Softball team)--Pictorial works. 3.
 Photography, Artistic. I. Sobieszek, Robert A., 1943- II. Title.

 GV881.3 .P39 2002
 796.357'8--dc21

 2002068405

Hardcover ISBN 1-57687-142-8

Separations, printing, and binding by Artegrafica, Verona

Publication Consultant Peter C. Jones

Edited and sequenced by Mark Holborn
Design Associate Doris Voigtländer

A complete catalog of powerHouse Books and Limited Editions is available upon request;
please call, write, or slide into our web site.

10 9 8 7 6 5 4 3 2 1

Printed and bound in Italy